WANDA GA'G

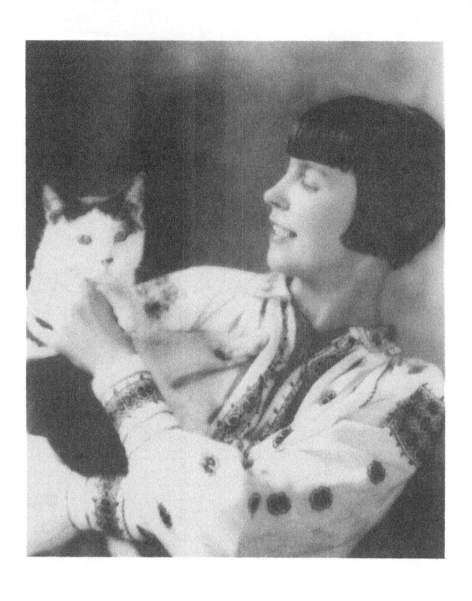

WANDA GÁG

STORYBOOK ARTIST

GWENYTH SWAIN

BOREALIS BOOKS

Author's Note: Wanda Gág began spelling her last name with an accent mark when she was an adult living in New York City, trying to get people there to pronounce her name correctly. *Gág*, she insisted, "should rhyme with *jog*, not *bag* please!" In this book, you will see two different spellings of Wanda Gág—*Gag* before Wanda added the accent, and *Gág* starting in the 1920s when she made the change.

Wanda was a stickler for details, so this kind of inconsistency might have driven her to distraction, had she lived long enough to read this book. However, what would bother her more is the thought that people might still be mispronouncing her family name. So, remember: both *Gag* and *Gág* rhyme with *jog*, not *bag* . . . please!

Borealis Books is an imprint of the Minnesota Historical Society Press.
www.borealisbooks.org

The Minnesota Historical Society Press is a member of the Association of American University Presses.

Manufactured in the United States of America

10 9 8 7 6 5 4 3 2 1

♾ The paper used in this publication meets the minimum requirements of the American National Standard for Information Sciences—Permanence for Printed Library Materials, ANSI Z39.48–1984.

Permission to quote from materials held in the Children's Literature Research Collections, the Van Pelt Library, and the personal collection of Gary Harm has been granted by the individual repositories.

Frontispiece: Wanda Gág with one of the cats used as a model for her book *Millions of Cats*

International Standard Book Number 0-87351-545-5 (hardcover)
0-87351-544-7 (paper)

Library of Congress Cataloging-in-Publication Data

Swain, Gwenyth, 1961–
 Wanda Gág : storybook artist / Gwenyth Swain.
 p. cm.
 Includes bibliographical references and index.
 ISBN 0-87351-545-5 (cloth : alk. paper) — ISBN 0-87351-544-7 (pbk. : alk. paper)
 1. Gág, Wanda, 1893–1946—Juvenile literature. 2. Illustrators—United States—Biography—Juvenile literature. I. Title.

NC975.5.G34S93 2005
741.6'42'092—dc22
[B]

2005041248

We do not live in fairy tales but they live in us,
endlessly growing, repeating their themes,
ringing like great bells.

P. L. Travers, 1943, from a newspaper clipping
collected by Wanda Gág

TABLE OF CONTENTS

ACKNOWLEDGMENTS

The author wishes to acknowledge the contributions of many individuals and organizations to this book.

For their willingness to speak with me about Wanda Gág, I thank the following persons: Gary Harm, son of Stella Gag Harm, and his wife, Dolly, who graciously welcomed me into their home to view their personal collection of family artwork and papers; Patricia Scott Keairnes, daughter of Alma Schmidt Scott; and James Boeck, curator of the Wanda Gág House, New Ulm, Minnesota.

For their helpful comments on the manuscript in progress, I thank the following individuals: Darla Gebhard, Research Librarian, Brown County Historical Society; Gary Harm; Karen Nelson Hoyle, Children's Literature Research Collections, University of Minnesota; Marcia Marshall; and Shannon Pennefeather.

For research assistance, I acknowledge the following people and institutions: Brown County Historical Society, New Ulm, Minnesota; Children's Literature Research Collections, University of Minnesota, Minneapolis, Minnesota; the reference staff of the Minnesota Historical Society library, St. Paul, Minnesota; Nancy Shawcross, Archivist, Department of Special Collections, Van Pelt Library, University of Pennsylvania, Philadelphia, Pennsylvania; and the Wanda Gág House Association, New Ulm, Minnesota.

I would also like to extend thanks to the organizers of and participants in a forum on Wanda Gág and her work held on April 25, 2004, at Landmark Center, St. Paul, Minnesota.

For their support of this project from its inception, particular thanks go to the staff of Borealis Books, to my friend Kevin Morrissey, and to my family, who led the charge in exploring all the nooks and crannies of Wanda Gág's house.

WANDA GA'G

Once in the early 1900s, when people still traveled by horse-drawn carriages and warmed their bath water on coal-fired stoves, there lived a storybook family. Everyone in the town noticed that the family was different. The father was thin, tall, and kind—"just like an artist should look." The mother was "small, and energetic," more like a lovely, lively sparrow than a person.

The five girls, all in flowing dresses that draped loosely over them, preferred playing barefoot in their grassy backyard to running in the streets with the other neighborhood children. It was understood, someone remembered later, "that they found complete enjoyment in their work & play at home." A neighbor, looking over the fence into that backyard, saw the girls hanging their stockings and underwear on the line. They worked and played and told stories until their mother called them in for dinner, and then they "always got up and ran into the house together—for all the world 'like a little flock of . . . birds.'"

What set these children apart, more than their clothes or their manner of playing, was the way in which they saw the world. When offered the choice between a penny and a pencil, each always chose the pencil—for writing or drawing. The oldest girl in particular saw the world through "piercing dark eyes." Her father hoped she might become a musician, but it was soon clear that "she loved drawing too well."

Too well for her own good, the townspeople said. Drawing wasn't practical. But the girl from the storybook family, the girl named Wanda Hazel Gág, proved them wrong. With her piercing eyes, she saw the world in new ways. And despite years of struggle, she learned to put what she saw onto paper, using both words and images to tell stories—just the stories you might expect from a storybook girl.

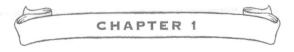

Wanda Hazel

It wasn't always a storybook life, but it was never gloomy. Wanda Hazel Gag was born on a cold Minnesota day—March 11, 1893. Her first home, between a saloon and a blacksmith shop in the small German town of New Ulm, was full of bedbugs. The wingless creatures hid in the baby's brown walnut cradle, nipping at Wanda's plump arms and legs. The Gags moved into more rented rooms, but they couldn't escape the bedbugs. Still, their new home was convenient. Both Anton Gag, Wanda's tall, artistic-looking father, and Elizabeth ("Lissi") Biebl Gag, Wanda's merry, birdlike mother, worked in a photography studio that took up part of their rooms.

Lissi had taken the job as an assistant in Anton's photography studio in about 1888, when she was in her teens. It was an odd choice of work for a woman. In those days women rarely worked outside the home, except as teachers or maids or cooks. And Christian women (Lissi, like Anton, was raised Catholic) *never* worked on Sundays, the busiest day for photographers. On Sundays, everyone in New Ulm was scrubbed, pressed, and looking their best. They were ready to have their pictures taken.

The advertisement in the photography studio window hadn't asked for a man or a woman or for someone willing to work on Sundays. It had asked for someone "artistic." Wanda's mother had worked only as a maid in a hotel, but she liked the idea of artistic work. She had an uncanny ability to make children smile and sit still, a great skill for a photographer's assistant. Lissi Biebl was also smart, pretty, and easy to get along with. She and Anton Gag married in 1892.

The Gag family's rented rooms were soon cramped and crowded. After Wanda, a sister, Stella Lona, was born in 1894. The Gags built a house, tall

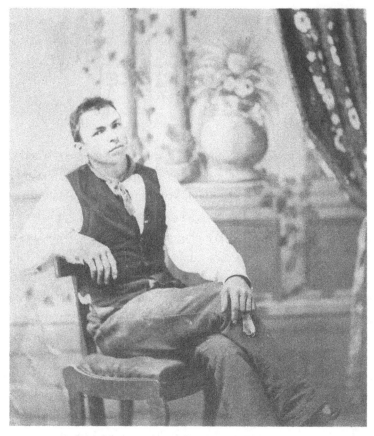

"An artist," Wanda's father, Anton Gag, once wrote, "wherever he goes and stands, whatever he does and produces, must always observe and gather and retain new impressions, teach himself and let himself be taught."

and skinny and brightly painted, on a bare lot at the edge of New Ulm on North Washington Street. But it was one thing to build a house, another to pay for it. When the house was completed, the Gags had to sell it to pay their debts. They couldn't afford to buy it back and move the family in until just before Wanda's fourth birthday, in 1897.

Anton set up the photography studio in a back room at the top of the stairs. He'd designed the room to be a studio, so it had large windows and a

Wanda's mother, Lissi Biebl Gag, considered herself to be "artistic."

skylit painting nook, for Mr. Gag was also a painter. The neighbors called him an impractical artist, and who wouldn't? Windows couldn't block the fierce cold of Minnesota's winters. "Think of the coal bills!" the townspeople said. Skylights in those days were nearly always leaky. The family kept a group of pails and pans nearby, ready for rainstorms.

In spite of the leaks and the cold, the studio and painting nook were inviting, at least to Wanda. That's where she often found her father. For as long as she could remember, Wanda followed her father around while he did his work as a photographer and while he painted for pleasure. In spare moments Anton Gag painted pictures of the countryside, views of castles in Bohemia

Wanda was often photographed by her parents even though she grew up
at a time when most people had their pictures taken only on special occasions,
such as for weddings or baptisms.

WANDA HAZEL

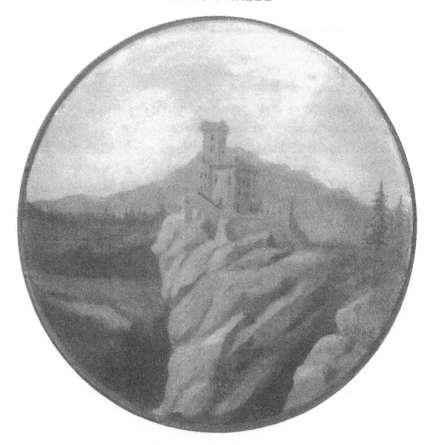

Anton Gag intended to train Wanda as an artist when she was older. In 1898, when Wanda was five, Anton painted this scene of the area where he was born, in a German-speaking part of Bohemia, a province of what is now the Czech Republic.

where he was born, and still lifes of carefully arranged fruit—fruit that looked good enough to eat.

Wanda knew that if she were well behaved, her father would let her eat the fruit after his painting was done. She learned never to interrupt him while he was painting. To occupy herself, Wanda looked at pictures in books stored in the painting nook's built-in bookcase. Or she drew pictures herself. Someday when she was a little older and he was a little less busy,

Anton Gag promised, he would train her to be an artist. Until then, he warned her not to copy the work of others. Wanda should draw her own view of the world.

Wanda and Stella slept in the room next door, sandwiched between the studio and their parents' front bedroom, with its door to a round, tower-topped porch. That porch, Wanda was delighted to discover, "offered excellent opportunities for climbing." In the hallway was another door, leading up to yet another skylit studio room in the attic. Wanda had never known so much space. She savored the elegant carpet-covered parlor downstairs, where her father played the zither late at night, the dining room with its tall cupboard full of drawers, and the kitchen, warmed by a large stove. Wanda was small enough—a slight, short girl with dark eyes and wavy dark brown hair—that even the crowded pantry off the kitchen seemed large.

Wanda and Stella had plenty of time to explore that spring as their mother grew larger and larger with pregnancy, then took to her bed. On April 4, Mrs. Gag gave birth to another girl, tiny and frail. Her parents named her quickly, in case she didn't live long. But Thusnelda Blondine (nicknamed Tussy, to rhyme with "pussy") proved stronger than she looked.

One of the neighbor ladies asked, "A boy or a girl?" Wanda was happy to say she'd gotten a new sister.

"What, another girl?" The way the neighbor lady said it told Wanda that not everyone liked girl babies as much as she did. When more sisters— Asta Theopolis and Dehli (pronounced "daily") Maryland—arrived in 1899 and 1900, Wanda must have noticed her father's disappointment. Without a boy, there was no one to carry on the Gag family name. Wanda also must have noticed her mother's growing exhaustion from caring for so many babies.

Though Mama was more tired than before, she turned plump and healthy-looking again in just two years' time. A new baby, Wanda knew by now, would soon be rocking in the brown walnut cradle. Papa, home from work and cranky from a sore tooth, paced the stairs. The kettle was on the boil, the house smelled of olive oil, and before long the doctor arrived. Wanda

and her sisters waited for the news. They saw it in Papa's face, lit with joy and a lopsided grin. At last, a boy! Just before Christmas, in 1902, Howard Anthony Jerome was born. As far as Anton Gag was concerned, the family was finally "complete." He was, he told people, "rich in children."

Wanda, almost ten years old, found it wonderful but also confusing. Surely her father loved her and her sisters. But the pure triumph on his face at the birth of a son made her question that love: "Had Papa really wanted a boy so much? And why?" Such questioning didn't bother Wanda for long. Her father's happiness at having a boy was so great it seemed to spill over into every part of the family's life.

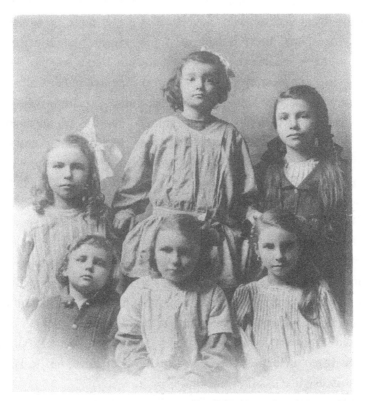

Six Gag children pose for their portrait in 1905. In the back row are, from left, Stella, Dehli, and Wanda. In the front row are, from left, Howard, Asta, and Tussy.

At home, Mrs. Gag was soon out of bed and doing all her usual cooking, cleaning, sewing, and combing (since all the girls had long hair). She took care of baby Howard and still found time to do little things for the girls, like baking bread shaped into square book shapes—*Bilder-Bücher,* or picture books, as she called them in her native German.

The children moved to different rooms, with the older girls taking over the old photography studio and painting nook. Now when Anton Gag wanted to paint on a Sunday afternoon, he headed for the attic studio, puffing on a rare cigar and humming old Bohemian tunes. As long as the children promised to be quiet, they could follow. To stay out of their father's way, the girls took over an unfinished room off the studio. There they played below the pointy front window with their marbles, paper dolls, china dolls, and doll furniture. And there Wanda drew pictures and told stories to her younger sisters, keeping them entertained while Mama watched the baby.

Surely some of the stories Wanda told were *Märchen,* or fairy tales. Wanda had gotten her taste for fairy tales from her mother's relatives, who lived on a farm just outside New Ulm. The "Grandma Folks," as Wanda nicknamed her Biebl grandparents, aunts, and uncles, were especially good storytellers. "Sit down, *Wandachen,* and I'll read you a *Märchen,*" grown-ups would tell her, speaking in German, as almost everyone in New Ulm did then. Settling into the lap of a grandmother or other relative to hear these tales had always given Wanda "a tingling, anything-may-happen feeling . . . the sensation of being about to bite into a big juicy pear."

Fairy tales were easy for Wanda to believe. The woods where Hansel and Gretel became lost were not so different from the "big deep forest" in Bohemia where as a boy Wanda's father had herded cows. Grandma and Grandpa Biebl's place was "all snug and tight," like the house of Snow White and the seven dwarfs. And it held just as many people: Grandma, Grandpa, three uncles, and three aunts. One aunt, Lena, was to Wanda "a princess in disguise . . . fine and fair."

Wanda discovered more and different stories once she was old enough for school. Kindergarten was all colored paper, glue, beads, and drawing,

and Wanda loved every minute. It was easy for her since the teachers and students spoke German, as Wanda did at home. Beginning in first grade, however, Wanda faced a confusing mix of mostly English and only some German at school. She found it hard to concentrate. At home, drawing was her favorite thing to do. At school, the teacher expected her to hold her felt-trimmed slate and write in chalk: 2 + 3 = 5. Numbers didn't mean much to Wanda, so she couldn't help daydreaming—and getting into trouble. At home, her father encouraged her creativity and dreaminess, saying proudly, "Na, my little Wanda is dreaming again!"

But some parts of school were wonderful. Miss Weschcke, who taught German through all of Wanda's years in school, liked to end her lessons with a fairy tale or two. And in Wanda's other, all-English classes, she gradually grew to love words. "When they're all together, so they make a story," she said, "things happen inside of you." Good things.

By fourth grade Wanda was allowed to borrow books from the school library, a small cupboard in the upstairs hallway. There, she found fairy tales and other stories nearly as good—*Hans Brinker, or the Silver Skates,* about a brother and sister who help their father recover from an accident, and *The Five Little Peppers and How They Grew,* about a poor family that manages to stay cheerful even after the father's death. Wanda brought them home and read them first to herself and then to her younger sisters. English words came easily to her now, and she devoured every book she could find.

Wanda's reading homework took forever, but not because she couldn't understand it: "When we have to look up words for the reading lesson I read and read in the dictionary because it's so interesting I can't stop . . . in between I always see other words which *make* me look at them." She liked the way words sounded when spoken out loud. She even liked the way words *looked* and could picture them in her mind during spelling bees at school. As she put it, "You see a word, and when you stand up to spell it, the picture of the word stays in your mind."

It wasn't like that at all with math. Wanda eventually learned to add and

subtract well enough. In fourth grade, she faced a new challenge: multiplication. Wanda might look at 6 x 7 = 42 in her book, but by the time she was called on to stand up in class, the answer had flown out of her brain, "erased just as if it had been on the black board and someone had brushed it out with the eraser so it's just black and empty again." Try as she might, Wanda simply couldn't picture numbers in her mind the way she could "see" her favorite words or the way she could see and understand shapes she wanted to draw.

One day her teacher, Miss Koch, had her stay indoors during morning recess to practice her multiplication, but Wanda still "got stuck." Miss Koch tried again at afternoon recess, but Wanda did no better. Finally she had Wanda stay after school. "She only let me go," Wanda remembered later, "because she didn't want to stay after school either."

Wanda worried that she would "surely stay sitting at the end of the year"—be held back. But she moved on up through the grades.

Two wonderful things happened in 1905, when Wanda was in seventh grade. She had been collecting favorite words and names for some time: words like *glen* or *dell* or *grotto* and names like *Gwendalyne* or *Marmaduke* or *Clover.* By seventh grade, Wanda was putting those words into stories. One of those stories, about a boy named Jocko, was ten chapters long. Wanda copied it carefully, trying to avoid making ink blots on the pages, and showed it to her father. He said it was pretty good for a twelve-year-old, and Wanda couldn't have been more pleased. Papa Gag insisted on perfection and rarely handed out praise.

The other good thing about that year was meeting Olga Mayer. Wanda had never before had a best friend. Maybe it was because she was nearly always the smallest in her class. (For years, one teacher called her *Wandachen,* or "Little Wanda" in German.) Maybe it was because she was so dreamy. Or maybe it was because she loved to draw and read until her eyes were so tired the doctor ordered her to bed in a dark room for a week. But in the fall of 1905, the Mayers moved in a few blocks away, and suddenly Wanda found someone who loved words as much as she did.

Together Wanda and Olga filled five-cent notebooks with stories they created. Often, Wanda illustrated the stories with her own drawings, signing them with elegant-sounding pen names like Hazel or Edythe Vernon Younge. Sometimes the girls snipped pictures from magazines and used them as illustrations. Words and names Wanda had collected found their way into stories, like the one about a girl named Velva Marche who finds a family living in a glen—a family with girls named Daisy and Clover White.

Wanda loved writing stories with Olga, but at times Wanda's tales showed signs of strain. In "Velva's Glen," from 1906 or 1907, Wanda wrote, "Mr. and Mrs. Marche found that the White children's parents were fairly well educated but . . . Mr. White . . . got sick and could not work so everything went out of order." Mr. White might just as well have been named "Mr. Gag."

Wanda's father, Anton, had been ill for some time. In the late 1890s, he had closed his photography studio. To feed his growing family, Mr. Gag

Wanda regularly walked through New Ulm's German-Bohemian neighborhood, named "Goosetown," on her way to visit Biebl relatives, or the "Grandma Folks," as she called them.

had formed a business to paint and decorate homes, churches, auditoriums, and other buildings. He had enjoyed some success, but years of standing while painting had left him with pain in his legs. As a young girl, Wanda superstitiously avoided stepping on the newest boards of the wooden side- walks downtown. Stepping on cracks could "break your mother's back," as the rhyme said, and Wanda knew that stepping on green boards was also bad luck. Maybe it could hurt her father's legs.

Even with all of Wanda's care, her father grew sicker. One foot was often bandaged so thickly that Mr. Gag couldn't wear a shoe. By 1906, Papa Gag's foot was the least of his worries. He was frequently too tired and sick to work. He rested for long stretches and had trouble breathing. Doctors diagnosed tuberculosis, a disease that ravages the lungs. Most likely, the doctors said, he'd gotten the disease while painting and decorating damp churches. Mr. Gag traveled to Oregon, hoping the coastal air would bring a cure, but he returned only slightly less tired than before.

Mrs. Gag seemed tired, too, although she was gaining weight. At some point Wanda realized her mother was pregnant again. Soon there would be nine mouths to feed, and not one of the Gags was strong enough to put in a vegetable garden.

Mr. Gag forced himself to keep working that winter and spring, traveling from New Ulm to Mankato to decorate churches. Only thirty miles separated the towns, but Mr. Gag had no car or horse to cover the distance. He came home only infrequently. He was away when a baby was born on May 24, 1907. Wanda, who believed that names should be "like music or flowers or perfume," helped name the girl: Flavia Betti Salome, whom everyone called Flops or Flopsy. Flavia's birth should have brought rejoicing. But Mrs. Gag was so tired, she had no energy to care for the baby. Wanda spent so much time watching her littlest sister, she almost considered Flavia to be *her* baby. And Mr. Gag couldn't help Wanda with the baby-watching, even if he had wanted to. When he returned home from Mankato, he took to his bed as well. Like the father in Wanda's story, Anton was so sick he "could not work so everything went out of order."

CHAPTER 2

Everything Out of Order

Twice that year Anton Gag took the train north to St. Paul, Minnesota's big, bustling capital city. But the doctors he visited there offered no hope. Even as he smiled wanly and talked of the lovely scenery on the ride, Anton grew sicker.

As the oldest child, Wanda was needed at home to clean the house and to watch after baby Flavia and young Howard while Mrs. Gag cared for her husband. In the fall of 1907, Wanda started attending high school, but she could only manage to go part-time. By Christmas it was clear that even those few hours away from home put too much of a strain on the family. Wanda was forced to quit school.

In the early 1900s, many people thought that any education beyond eighth grade was unnecessary for a girl, unless she planned to be a teacher. Wanda had no thought of teaching. Although she was only fourteen, she knew—and had known for a long time—that she wanted only one thing in life: to be an artist, like her father. But even though Wanda's father was home now all the time, he was too ill to teach her what she yearned to know about drawing and painting. Wanda herself was too busy to draw—too busy cooking meals, scrubbing floors, doing laundry, and looking after Flavia and Howard. She was even too busy for storytelling. Olga Mayer, her writing friend, drifted away when Wanda stopped going to school. In March, her fifteenth birthday came and went in a blur of work and worry.

In the spring of 1908, Wanda helped Lissi Gag settle Anton into a bed in the front parlor, where it would be easier to care for him. The parlor was the house's fanciest room, one Mr. Gag had painted and stenciled himself. It was the very same room he'd once filled with zither music so beautiful and

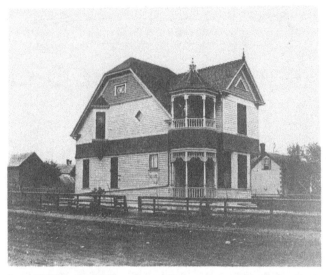

In spring 1908 Wanda's father, Anton Gag, was moved into the front parlor
(with windows to the right of the rounded porch) in the family's tall and skinny
house on North Washington Street in New Ulm.

sad it had made Wanda cry when she heard it at night. Now, Wanda real-
ized, it was the room in which her father might die.

One May day, while Mrs. Gag hovered close by, Anton called his daughter
to his side. Speaking in German, he told her how much he believed in her
abilities as an artist. Then, growing weaker, he said, *"Was der Papa nicht
thun konnt, muss die Wanda halt fertig machen"* (What Papa was unable to
accomplish, Wanda will have to finish). Anton Gag never spoke coherently
again. By May 22, 1908, he was dead at the age of forty-nine.

When Wanda first heard her father's words—"What Papa was unable to
accomplish, Wanda will have to finish"—she was in too much of a daze to
know what he meant. All she realized was that her father was dying. But
slowly the meaning of his words sank in: He was telling her to do what she
had dreamed of doing. He was telling her to be an artist. He was telling her
to finish the work he had started. He was thinking, Wanda said later, "of the
pictures he had not finished—had not even begun."

EVERYTHING OUT OF ORDER

Nothing about the future was clear during those late spring days. Anton Gag left behind seven children, a sad and tired widow, and very, very little money. The only bright moment came on the day of Anton's funeral. Flavia, the youngest Gag, took her first steps.

If Wanda had asked her neighbors in New Ulm what to do, their answer would have been clear. Most people in town thought it best that Wanda leave behind any dream of drawing and school and find a job. In fact, they assumed she would do that very thing. Perhaps she might be hired as a clerk in a store. In time, Stella (nearly fourteen), Tussy (just turned eleven), and Asta (almost nine) could follow and help support the family.

Wanda drew on almost any scrap of paper she could find,
as this portrait of Dehli on brown paper, from about 1908, shows.

But Wanda didn't have to ask the neighbors for advice; they gave it freely. For a strong-willed girl like Wanda, being told what to do was hard to swallow. If she were to become an artist, she knew she would first need to finish high school, then somehow find her way to art school as well.

Papa never meant for her to "finish his work" as a clerk in a store; Wanda was sure of that. Her mother, too, had heard Anton Gag's dying words. Lissi Gag was sympathetic to her oldest daughter's plight, but there was a very serious question to answer: How could they keep the family together on the meager insurance money Mr. Gag left behind and eight dollars each month from the county for food?

At first, Lissi looked for work in a photography studio, but there were no openings. She took in laundry for a while even though she was scarcely strong enough to do the wash for her own seven children. There were times when Mrs. Gag would lie down for a rest and stay in bed all day.

Wanda knew how to keep her younger sisters and brother entertained: she told them stories. *Märchen,* in particular, often had happy endings, positive outcomes that seemed to be missing at the tall, skinny house on Washington Avenue. Another thing that seemed to be missing was food. Wanda quickly learned to cook a passable dinner for seven, even if the results weren't always tasty.

When it became clear that her mother was too weak to work, Wanda began looking for a way to earn money herself. It had to be a way that Wanda chose, and one that would allow her to go to high school again someday, if Mrs. Gag could ever spare her help at home. That ruled out clerking in a store, since school would be impossible then. Instead, Wanda set out to earn money doing what she'd always done for fun.

Always before, she'd drawn pictures and written stories out of sheer enjoyment. Now she entered the art competitions at the county fair hoping to earn prize money to bring home to Mama. She took orders for hand-drawn place cards that New Ulm's society ladies put beside plates at fancy dinners and teas. She asked Mr. Eggen if he would care to sell her hand-painted "postals," or postcards, at his store downtown. (He agreed, and that was how

EVERYTHING OUT OF ORDER

Wanda earned money drawing cards that were used at dinner parties to indicate where guests were to sit.

Wanda paid off the $1.13 cost of school books for the other Gag children.) Late in the fall, Wanda bought preprinted calendars for 1909, pasting them onto her own background pictures and selling them wherever she could.

Wanda didn't just sell her art in New Ulm. She searched the drawers at home for postage stamps and sent her work to contests at magazines such as the *Woman's Home Companion* and *McCall's* or to the pink-paper insert in the *Minneapolis Journal* called the *Journal Junior.* These magazines and newspapers sometimes paid for poems, stories, and drawings—even poems, stories, and drawings by teenage girls.

Mae Harris Anson, editor at the *Journal Junior,* gave Wanda her first long-term assignment. After Wanda sent her some drawings and stories, Anson ordered an illustrated story, "Robby-Bobby in Mother Goose Land," to appear in several issues of the *Journal Junior.* Wanda earned twenty-five dollars for this work, as much as a clerk might earn in a month. Almost better than the pay was the package Anson sent: it held drawing paper, pencils, pens, erasers, and bottles of black ink. Wanda was thrilled—and relieved. She had already used up nearly every scrap of paper left at home.

WANDA GÁG

MANY A life
is yours
to save,
for you'll
be a doctor
brave.

Wanda drew pictures for sale for almost every occasion, including Valentine's Day.

In the fall of 1908 Wanda found one of her father's old ledgers. Instead of drawing on its lined sheets, she started recording the family's expenses. On a rainy, dark October day, she stopped to record her progress:

Rec'd (for painting		1907 Fair Money	$.50
postals) $3.95		1908 Fair Money	.75
Cost	.51 1/2	Prize from W. H. Companion	1.00
Gain	3.43 1/2		1.75
	$1.69		
	3.43 1/2	6 cts. stamps for sending	.06
	.10 for stamping table cover		$1.69
Total gain: $5.22 1/2			

EVERYTHING OUT OF ORDER

Wanda's math wasn't perfect. (She earned more in fair and prize money than she thought.) But her "total gain" of less than six dollars still helped buy important "extras" like shoes (at $1.75 a pair) or Christmas nuts (ten cents a bag) or, when Papa's ledger ran out, a new five-cent notebook to use as an account book and diary. For, along with a record of her earnings, Wanda wrote down the details of everyday life: what new words Flavia was saying, what the weather was like, how cold the house was, and how the day-old rolls Wanda bought at the bakery were so bad the children wouldn't eat them, "so we didn't have much for supper."

With Wanda's earnings and with what Stella was paid for babysitting jobs, the family managed to survive. And in January 1909, Mrs. Gag was feeling well enough that she agreed to her oldest daughter's wish. Wanda could return to high school part-time.

Sometime in that first year after her father's death, Wanda had come to an important decision. All of the Gag children, she vowed, would study not just through eighth grade but all the way through high school. That way, they might someday find better-paying jobs than those of clerks or maids. And Wanda herself would be qualified to enter art school, if ever she found the money to pay for it.

Wanda knew it might be difficult to carry out her plan, and in the spring of 1909 her chances of success grew even more remote. Mrs. Gag's strength and spirits weren't recovering. On good days, Wanda's mother was well enough to gather edible greens, such as dock, lamb's-quarters, and dandelion leaves, that grew wild in the fields around town. But good days were few. At some point after Anton's death, Mrs. Gag confided to Wanda that she had "nothing to live for." Certainly she loved her children, but the loss of her husband and her own inability to find paying work were tearing her apart.

In the same book where Wanda recorded her earnings from painting and drawing she wrote, "Mama is sick since last night . . . I was so scared I was trembling all over." And a few weeks later, "This afternoon I didn't go to school because mama didn't feel well. She was in bed nearly all day. I'm

hungry. We had only doughnuts, beefsteak and butter bread this evening, and I don't care for beefsteak."

Finally the family doctor, seeing that Lissi was overtired, prescribed lots of rest—and the local beer, called Tonic. In New Ulm, the Schell brewery was one of the town's most important businesses. Beer in those days was seen as a cure for many ills. Lissi drank the "tonic," but as she followed the doctor's orders, she gradually grew dependent upon alcohol.

Years later, Wanda remembered this turn of events as "the tragedy of mama's life . . . that such a gay little birdlike creature had to be so beaten down by Fate!" When she was young, Wanda bristled if she heard people in New Ulm gossiping about her mother's drinking.

The gossip that bothered Wanda most, however, was the gossip about her. She recorded rumors big and small in her diary: "A few days ago Margaret Kelly told me that Martha Schmid didn't believe I drew free hand. She thinks I trace. Trace indeed!" And, "Fern Fischer was here yesterday and she said that somebody told her that I don't do anything but read and draw. I guess I do! I wonder if washing dishes, sweeping about 6 times a day, picking up things the baby and Howard throw around are reading. And I've never heard of taking care of babies, combing little sisters, cleaning bed rooms & attics as being classed as drawing!"

Sometimes Wanda felt as if people in New Ulm wanted to remake her into a girl who didn't read and write and draw with a fury. Local gossips made her feel guilty for doing what she couldn't help doing, even if she'd wanted to stop. She asked herself, as she put it later, "How much of me did they really need—all? How much did I belong to myself? To what extent had I the right to ignore myself—not the physical part that walked around and worked, but that fiery thing inside which was always trying to get out and which made me draw so furiously?"

Despite the small-town gossip, Wanda kept drawing and reading and writing. And not long after she started back at school she found a new friend who didn't make fun of her efforts, someone who understood her just as Olga Mayer once had.

CHAPTER 3

Strivings

"Schmidty." That was Wanda's nickname for her new best friend, Alma Schmidt. In turn, Schmidty dubbed Wanda—always drawing or writing and eternally ink-stained—"Inky." Together, the two took long walks in New Ulm, crossing the Minnesota River and going up the hill to where a statue of an ancient German hero, Hermann of Cherusci, overlooked the town. They discussed their teachers at high school, books they read, and issues such as marriage and what to do if a boy wanted to kiss a girl's hand.

Schmidty, though not an artist herself, also tried to understand Wanda's passion for drawing. Sometimes, Wanda told her friend, she was overtaken by the *need* to draw. She felt she had to draw anyone or anything around her. As she put it in her diary, "When I am in a drawing mood: 'Not all the king's horses, nor all the king's men, can get Wanda to do her lessons, or other things again.'" Wanda called these her "drawing fits."

Schmidty's older sister, like almost everyone else in New Ulm, thought Wanda's fits were plain peculiar. She asked, *"Na was ist denn das? Eine Krankheit?"* (What is it then? A sickness?). But Schmidty thought Wanda's drawing fits were dreamy and romantic, just as Wanda did.

On early morning walks in the summer, Wanda made up a game to help Schmidty see the world as an artist does. In the "Shadow Game," Wanda would point to a shadow cast by a tree or house or statue and ask Schmidty to describe the shadow's color. As far as Schmidty could tell, all shadows were gray. But Wanda helped her see the shading. Over months of Shadow Games, Schmidty started seeing subtle shadings of green and gray and yellow even in simple shadows.

Back at home in Mr. Gag's old attic studio, Wanda sketched Schmidty

or the younger Gags whenever she had a chance to draw for fun and not for money. Those chances were few and far between. "Oh dear," she wrote in her diary, "I wish I could earn a pile of money so that I could draw a little for myself, and so that I could go to school without having to think of quitting." But things weren't getting any easier for the Gag family. When Wanda became handy at remaking the cast-off clothes people gave the family, town

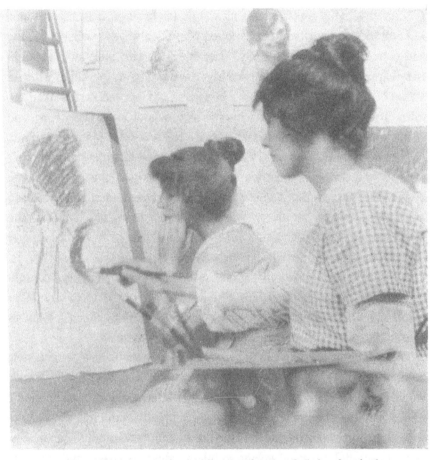

When Wanda was in the middle of a "drawing fit," she sketched everything and everyone around her. Here she sketches her sister Stella in the upstairs attic bedroom the two shared.

gossips criticized the Gags for "dressing so swell"—better than a poor family had any right to. The Gag children tried to stay cheerful, like the family in *The Five Little Peppers,* but being poor was wearing them down. Wanda shared her only sweater with her sister Stella. The family became used to dinners of cheap, day-old bakery rolls. Wanda's fingers grew blistered when she had to chop wood for the kitchen stove.

"It just strikes me that it's rather 'story-bookish' to be poor," Wanda told her diary. But, she concluded, "it's no *fun* to be poor." The dramatic or romantic qualities of poverty—what made for good stories in books—didn't help Wanda in facing the day-to-day reality. "It isn't nice to go shopping with about 3 dimes and four pennies," she wrote in her diary. "I feel as if I could cry quarts of tears only I shan't."

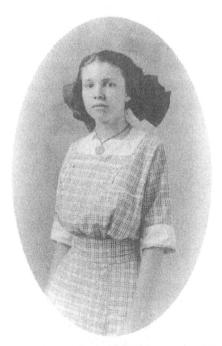

In 1910 Wanda won second prize in a statewide art competition for young people. The letter that came with the prize (a medal) stated that Wanda "is on the right road and fortunately has formed no bad habits so common to the self-taught [artist]."

It was that decision—not to cry quarts of tears—that helped Wanda survive. Instead, she did other things, from silly to serious, to keep from getting gloomy. Around the dinner table at night, the Gag children turned their lack of food into a game. Wanda divided what they had into equal shares and, without saying anything aloud, numbered them from one to seven. Then the younger Gags called out numbers, and Wanda handed them their portions. Or, if playing the "Eat Fair!" game didn't improve a poor meal, the children might pretend: "we're trying to satisfy ourselves by imagining things. Isn't it quite fairy tale-ish? Just like the man in the *Arabian Nights* who imagined he was eating a fine meal—isn't it?"

With Schmidty, Wanda counted "hat-tips," the number of times grown men and boys tipped their hat to her as a greeting. (She was hoping that the 101st hat-tip would be from the man she would marry, but it was old Mr. Knispl instead.) When it seemed that art school—like a handsome hat-tipper— would never be more than a dream, Wanda began winning awards. First she won a special award for drawing: five silver dollars! Then the St. Paul School of Art had a contest for pencil sketches, and Wanda's drawing of Stella won second place out of entries from the whole state of Minnesota.

During a trip she made with Schmidty to the Twin Cities of Minneapolis and St. Paul in 1911, Wanda even began to meet people who thought she had potential as an artist, not as a clerk in a store. Perhaps the most influential of these was Tyler McWhorter, a cartoonist for the *St. Paul Dispatch* and the manager of the St. Paul School of Art. When McWhorter discovered that Wanda was visiting the Twin Cities, he asked her to come to his office. He had seen her work in previous contests and wanted to be sure she continued studying art. When he shook hands with Wanda he told her, "Any time you are ready to come to art school, just write to me and we'll find some way for you to go."

What did he mean? Wanda wasn't quite sure. All through her senior year in high school, she puzzled about her future. Would she be able to go to art school after graduation? And if she did go to art school—and stopped earning money for the family—how could her older sisters afford to stay in school?

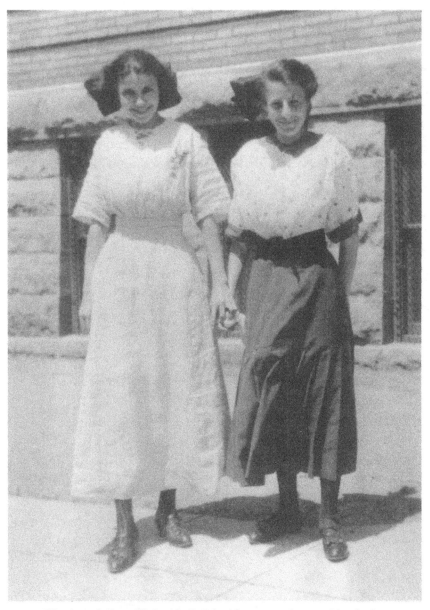

Wanda and Alma ("Schmidty") Schmidt were such great friends that other students in the class of 1912 predicted that the two would still be buddies forty years later, in far-off 1952.

Finally, Wanda set out to do what she *had* to do, even though it was not what she *wanted* to do. If she could teach at a one-room country school, she might earn more in a month than she could hope to make in a year of drawing place cards and entering contests. The trouble was, Wanda hadn't prepared for a teaching job. She managed to pass the major exams, but her arithmetic and handwriting grades were so poor they might disqualify her.

Wanda peers out from behind her teacher, Miss Gould, in about 1912.
"How we revelled in English Lit., & Miss Gould's influence—the first person who thought I could write," Wanda wrote to her friend Schmidty when thinking back to their high school years.

Only a school that wasn't too choosy was likely to take her. Fortunately for Wanda, one school did, just before classes started in the fall of 1912.

Teaching all eight grades at District School No. 59, a long ride west of New Ulm near Springfield, had nothing of the storybook about it. Still, Wanda managed to turn the experience into poetry:

> Each morning eighteen pairs of eyes
> Look in at the open door.
> Each morning eighteen pairs of feet
> Track up my spotless floor.

In the one-room school, Wanda suddenly found herself working as janitor (starting the coal fire each morning and sweeping floors each night), nurse (bandaging cuts and nursing bruises), referee (trying to stop fights during recess), mother (caring for the youngest students), and, lastly, teacher. Into the bargain, she offered art instruction and had taken up guitar playing, in case the school had no piano or pump organ. For her work, she received forty dollars per month. In 1912 that was good pay, particularly for a nineteen-year-old with no teacher training or experience.

Wanda found that her lack of experience wasn't much of a problem: the students liked her free-wheeling approach and the art projects she would start at a moment's notice. They loved it when she tried to play the guitar. But her size was an issue. Many of her oldest scholars were heads taller than she was. It was challenging to keep an orderly classroom as a small teenager, even if she piled her hair on top of her head to look like a taller, grown-up lady. Wanda didn't care to whip disobedient students even though, as she wrote in her diary, "Most of the people here think one should whip children systematically as part of the daily routine."

Lessons and recitations didn't always go smoothly in Wanda's schoolhouse. In fact, she admitted later, "the situation got pretty much out of hand at times and occasionally pandemonium reigned supreme." To her diary, she said, "Of course I know I was never cut out be a school teacher but I *did* think I could do it better than I am." Wanda wasn't the only person who

hoped for better. The county school superintendent was hearing complaints from parents. When he investigated, he found the scholars doing all kinds of work (mainly drawing and what Wanda called "busywork") that wasn't part of the approved curriculum. But he stayed long enough to see that Wanda's scholars were also learning all of the required subjects. Wanda's methods, though unusual, were working. The superintendent decided not to interfere.

Wanda's term as a schoolteacher flew by, and when summer arrived and classes ended, she knew two facts. During the nine months of the school term, she had never been hungry. She'd boarded with the Roiger family on their nearby farm, and for the first time in years she'd eaten her fill at every meal. But during all the time she'd been in charge of a classroom, she hadn't had a single drawing fit.

Certainly she had drawn—bookmarks for one of the Roiger girls she'd become friends with and other little sketches. But never once had Wanda been overcome by a *need* to draw. Was she the same person who had declared in her diary, only a few short years before, "My Own Motto— Draw to Live and Live to Draw"?

Her father, she knew, hadn't spent so many winter Sundays in his cold attic studio because he *liked* to sketch and paint. He'd always drawn because he *had* to. Wanda was concerned and even a little scared when her drawing fits left her. If she didn't draw with a passion, she couldn't very well fulfill her father's wish and finish the work he had begun as an artist. For the first time in her life, she worried that her passion had deserted her.

CHAPTER 4

Leaving New Ulm

In the early summer of 1913, Wanda moped. Her head felt empty. "I haven't a hint of inspiration in my intellectual dome," she told her diary. "I don't know what the matter is with me, I can't buckle down and do anything lately—I haven't the patience for sewing, writing and even drawing." Her sketchbooks stayed blank. Wanda could pour her feelings into her diary, but she still longed to draw: "I haven't had a drawing mood since last August—isn't that awful?" With Schmidty out of town, she longed, as well, for "someone to talk to at last!"

Then in midsummer, during one incredible week, her drawing fits returned and she made a new friend. The place was University Week in New Ulm, a series of lectures, classes, and concerts sponsored by the University of Minnesota. Professors and students traveled south from the Twin Cities to take part. New Ulm residents were especially invited to attend. Wanda went to sketch the crowd and quickly befriended a young college student named Edgar Hermann. He was unlike anyone she had ever met before. He was intelligent and opinionated. He spoke "a very polished English, a very fine German too." Most important, Edgar was convinced that Wanda should go to the university in the Twin Cities.

He spoke so forcefully that Wanda was half-convinced, too. For a few weeks she wandered around New Ulm dreaming of going to the university or to art school. And then, in what seemed like nothing short of a miracle, her dream became real.

Charles Weschcke, a wealthy man from St. Paul with connections in New Ulm, came to visit the Gag family. Weschcke had known Wanda's father and admired his work as an artist. His sister was one of Wanda's teachers in

WANDA GÁG

New Ulm. And he had met Wanda during her term as a schoolteacher. That summer he arranged with Tyler McWhorter, manager of the St. Paul School of Art, to have Wanda admitted as a student there in the fall. He even offered to pay for her classes and for a room and meals at the YWCA.

Wanda couldn't believe her good fortune. Her oldest sister, Stella, just graduated from high school, had found a job teaching at a one-room school. Wanda didn't have to worry about supporting her family. Stella would step in for now.

"I am to go to Art School!" Wanda wrote Schmidty as soon as Mr. Weschcke left the house, "and I'm not to do anything but 'the thing I was meant to do' as Mr. Weschcke expresses it. Would not that be ideal?"

While Wanda went to art school in the Twin Cities, Stella, left, taught in a rural one-room school to support the family in New Ulm.

LEAVING NEW ULM

Living in St. Paul and attending art school was a great adventure for Wanda,
far right, shown here with friends.

It might have been "ideal" if Wanda Gag had been a different type of
student. But she was never the kind of person who did something simply
because others said she ought to. After all, she hadn't become a clerk when
nearly everyone in New Ulm was suggesting that she should.

In St. Paul that fall, when her teachers asked her to draw sketches from
plaster copies of great classical sculptures, she refused to hand in assign-
ments. ("The work I did on them was poor. . . . It would have been an insult
to my muse to have turned them in.") When they asked her to sketch a live
model in class, she hesitated before drawing her first line, to make sure it
was right. (Her classmates and teachers thought she was dawdling and
lazy.) At the YWCA, she wouldn't turn out her lights at eleven o'clock if a
drawing fit was upon her. To trick the matron who checked after "lights
out," she put black paper over her transom window and stuffed rags under
her door. ("How could anyone even *think* of turning lights out on a drawing
mood?" she asked.)

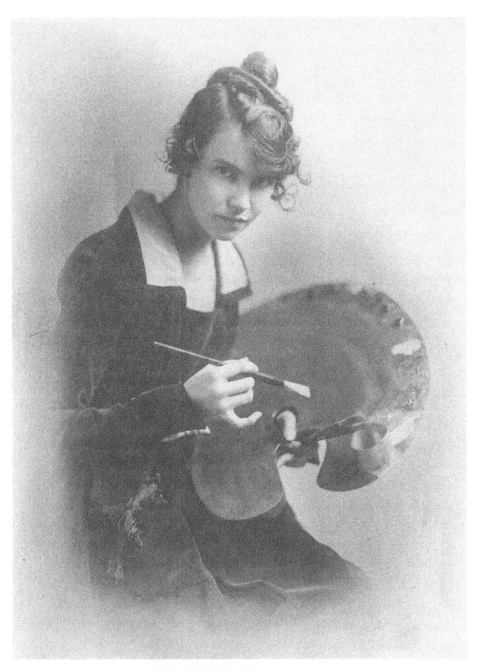

Wanda put on the classic "artist's pose," with an oil painter's brush and palette, while studying art in Minnesota.

Sometimes Wanda's teachers wondered if art school was less important to her than discovering the sights of Minneapolis and St. Paul. With Edgar Hermann, Wanda went to concerts or took long walks to discuss poetry and art. Schmidty was attending the University of Minnesota, and Wanda frequently met with her for walks and talks as well, the two swishing down the sidewalk in their ankle-length dark skirts and white blouses. They looked like the dreamy-eyed Gibson Girls of popular magazine illustrations, idealized young women who dressed in stiffly starched shirts with needle-thin-waisted skirts and who wore their hair in billows on top of their heads. Gibson Girls might be adventurous enough to learn to ride horseback or play golf, but they had no ambitions beyond marriage and child-rearing.

Perhaps Wanda's sponsors, Charles Weschcke and Tyler McWhorter, wondered about her ambition and commitment to art school. After her first year of studies, Wanda hoped they would pay her way again. But they never offered.

Back in New Ulm, Wanda was at loose ends. At twenty-one, she might have found another job in a one-room school, but she didn't want to be stuck in the country. She might have submitted illustrations to magazines, as she had done when she was younger. But a year in art school had given Wanda new ideas and worries. If she did too much commercial art—what she called "clever" art—would she be able to unlearn those techniques later and produce great, fine art?

Wanda knew her family needed the money her art might bring. But she found she couldn't make herself draw for money. "I am so *selfish,* I am so selfish," she wrote in her diary, "I do not want to harm my art." She didn't dare confide in her mother: "Mama has so much to think about as it is that I don't want to bother her with my affairs." Stella and Tussy found her to be just plain gloomy: "They told me this morning that I was so 'melancholy' that I had a depressing effect on their spirits."

By fall 1914 Wanda managed to push aside her fears of clever, commercial art. Tyler McWhorter, her old sponsor, still declined to help her return to art school. Instead, he found her a job drawing for a St. Paul design company

for three dollars a week. While Wanda would earn less than a third as much as her sister Stella would teaching, at least she would be drawing. And the job would give her a chance to return to the Twin Cities while paying her own expenses.

Soon, however, Wanda discovered that doing commercial art for a living was more challenging than she expected. She wrote in her diary, "I dare hardly draw after I get home after having drawn all day." Then she worried about writing in her diary so much: work had put a strain on her eyes. Still, Wanda kept at her job and managed to pay for her room and board. (For a new dress suit, she had to ask Stella for money.) And she dreamed that something better might someday come along.

That's when new sponsors stepped in. In November 1914, Wanda met with A. J. Russell at the Journal building in downtown Minneapolis. Russell, who had taken over as editor of the pink-paper *Journal Junior,* had been impressed by old drawings of Wanda's that he'd found in his office. He shared them with Herschel Jones, the newspaper's managing editor, and Jones was equally impressed. At the Journal offices, Russell introduced Wanda to Jones, who asked her what she was earning each week at her job. "Five dollars," Wanda answered. (She had gotten a raise.)

Mr. Jones snorted and then said, "Do you want to go to Art School here in Minneapolis with all your expenses paid?"

Jones said it as if he hadn't quite decided, so Wanda wasn't as bowled over by the offer as she might have been. Instead of saying "YES!" she told him about her younger sisters and brother and how she wanted them all to graduate from high school. Shouldn't she be unselfish and sacrifice herself for them? Shouldn't she put art school on hold? These were the arguments Wanda often made in her diary.

Jones wasn't worried about such things. When Wanda said she wanted to earn more money as soon as possible to help support her family, he simply said, "Well, I'll look into the matter."

Late in the fall term of 1914, Wanda enrolled at the Minneapolis School of Art, housed in the Minneapolis Institute of Arts. She moved into the

nearby Woman's Boarding Home on Tenth Street. Wanda still followed the pull of her "drawing fits," but she also tried to do her assignments in school, even when she didn't much enjoy them. She was determined to not disappoint her new sponsors, and Jones and Russell continued to give her support and encouragement for the next two and a half years.

After her first year of art school, Wanda often drew with pastel pencils. When no one would agree to pose for her, she drew herself while looking in the mirror. Even when she was fully grown, Wanda was never large. (She was not quite 5 feet 4 inches tall and weighed less than 100 pounds.) Being so small, she always looked several years younger than her actual age.

WANDA GÁG

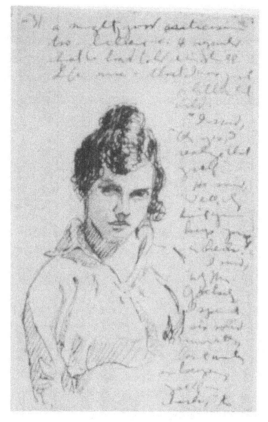

Wanda continued to write—and sketch—in her diary throughout her life.

During those years, Wanda earned some money designing covers for the *Minnehaha,* the student magazine of the University of Minnesota. But Stella, and Tussy after her, did most of the work of supporting the family in New Ulm. Later, Stella admitted that she and the others might have wished to go to art school or college, but she "couldn't go on to school and that was that." No one envied Wanda for her chance at schooling, but they did miss her at home.

Things were especially hard for the "kids," as Wanda called them, in January 1917. Winters were always cold in Minnesota, but they were colder

still in the house on North Washington in New Ulm. Late in the month, as a blizzard raged, Mrs. Gag, already weak from tuberculosis, became seriously ill with influenza. Wanda returned home and was at her mother's side when Lissi Gag died on January 31. The situation was painfully familiar. It was just as it had been with Wanda's father, nearly nine years before. Wanda later said that her mother "had been fading away before our eyes" for years and then had simply "given up."

Now the long-expected had finally happened. The Gag children were orphans, and Wanda was truly the head of the family. Even though several of the Gags were grown (Wanda was nearly twenty-four, Stella was twenty-two, and Tussy was almost twenty), the four youngest were still in school, with Asta and Dehli soon to graduate. People in New Ulm suggested that Flavia, just nine, and Howard, age fifteen, be adopted. Wanda insisted that the family stick together.

If Wanda were to earn money to support "the kids," then she needed to complete her art degree at the Minneapolis School of Art. She would have her degree if she could just stay in school through June. Until then, Stella and Tussy would continue to support the family. And the four youngest in New Ulm would remain in school.

Asta, in charge at home, reminded the younger Gags that, with Mama watching them up in heaven, they should all try to do their best. But the winter was hard. As Flavia remembered later, "Mittens wore out at the fingers. Stockings wore out at the knees, showing our 'union suits' [long underwear] underneath."

Maybe later they would sell the house and move. But for the time being, no one knew what the future might hold. By the spring of 1917, the United States had declared war on Germany, entering Europe's Great War (later known as World War I). Young American men—including many of Wanda's friends at art school—worried about being drafted.

To those worries Wanda soon added another bittersweet concern. In the spring of 1917, she and a close friend at art school, Adolf Dehn, both won scholarships to the prestigious Art Students League, a school in New York

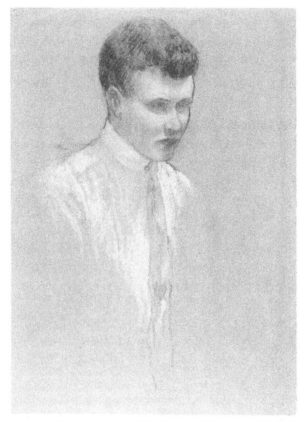

At art school in Minneapolis, Wanda met fellow artist Adolf Dehn,
shown here in a portrait she drew in about 1915.

City. Wanda and Adolf were two of just twelve students from across the
country to be awarded scholarships. Wanda was thrilled, but she immedi-
ately began to wonder if she *could* or *should* take the scholarship. Should
she remain in school when she might instead be working to support her
family? Should she pass up this opportunity to go "East," as everyone called
New York? She might earn even more money if she could break into the
magazine illustration field in the big city. But she wasn't sure she could bear
to leave her family behind. At the same time, if she stayed in Minnesota, she
might never see Adolf again—and Adolf was saying he was in love with her.

LEAVING NEW ULM

Wanda struggled with her decision. She had paid work for the summer, illustrating a volume called *A Child's Book of Folklore*. She and Stella and Adolf were also repainting the house in New Ulm to make it ready to sell. She hoped that if the house sold, the youngest children might use the money to move to Minneapolis and finish high school there. Stella and Tussy had taught long enough in isolated one-room schools. They now both hoped to

Wanda's friends didn't always see her as she did. Compare this caricature of Wanda, made by fellow art student Adolf Dehn, and Wanda's self-portrait on page 39.

find work in the Twin Cities and to live there with "the kids." But the house didn't sell quickly, and Wanda's own plans remained uncertain. Finally, her friend Herschel Jones at the *Minneapolis Journal* promised to help pay her costs at the Art Students League—the room and board that her scholarship wouldn't cover. In September, she boarded a train. Wanda, along with Adolf Dehn, was bound for New York.

Sink or Swim

Wanda quickly settled into classes at the Art Students League and her room at the Studio Club, a boardinghouse for women. She attended classes and visited museums, often with Adolf Dehn. Together, they gazed at modern paintings by artists such as Paul Cézanne and Pablo Picasso, whose works had not yet reached Minnesota.

These artists drew human figures that looked nothing like the copies of classical sculptures Wanda had studied in school. Their landscapes were unlike any of the hills and mountains that had unspooled outside the windows of Wanda's train on the ride to New York. Instead of drawing figures and things as they *were,* modern artists were drawing them as they *seemed.* These artists were more interested in conveying the essence of a person or a place than in displaying the exact details. If the public wanted exact copies of reality, modern artists seemed to say, then the public should look at photographs.

Wanda found such modern attitudes toward drawing exciting and exhilarating. With the help of her teachers and fellow artists, she struggled to put the images she saw in her mind—images that conveyed the essence of things—onto paper. As always, Wanda drew and drew the world around her. But at the Art Students League, she also learned how to make prints.

Some were linoleum block prints, made by cutting an image in reverse on a layer of linoleum (the same pliable material used on many kitchen floors). After covering the cut block with ink, Wanda pressed paper against it and pulled a "print" of her picture. She used the same basic technique with wood blocks, which are harder to cut into and require greater skill and precision. Eventually, she even learned to make lithographic prints, using a

special crayon to draw an image onto a lithographic stone or a metal plate. With great patience and care, she inked the stone or plate and printed her art. Each kind of print required different skills and different techniques for transferring the image inside Wanda's head onto paper. But all three methods were relatively inexpensive, and so they appealed to Wanda, who never had enough money.

Wanda was not the only Gag to feel poor during the winter of 1917 and 1918. Stella had moved to Minneapolis, where Tussy was taking secretarial courses. Both hoped to find work but didn't succeed immediately. To their oldest sister in New York they wrote long letters full of concern for "the kids" back in New Ulm. "They're almost starving at home," Stella wrote that fall, "Maybe some day we'll have it better."

Tussy had the same story to tell that January: "The kids have only $55 left. . . . But $55 will not last long. They are squandering absolutely none. In fact, they are not eating enough." By then Stella had found a job and could send money to New Ulm, but she had disturbing news: "Those foolish kids there they made up there [sic] minds to go without breakfast. . . . They are hungry alright even though they say they aren't." All four of the children still at home had moved into two downstairs rooms after pipes burst in the basement, making it impossible to use the furnace. "You must borrow money soon," Tussy pleaded.

Wanda sometimes stayed home from classes to earn money doing commercial art. She left the Studio Club for a cheaper room on Lexington Avenue. And she hoped and prayed that the house in New Ulm would sell. When it hadn't sold by the end of her first year at the Art Students League, she returned to New Ulm for the summer. There, she worried about the house and her family's future—and about Adolf Dehn. Adolf was drafted into the army in July 1918. Although he opposed the war for reasons of personal conscience, he wished to serve his country. For the rest of the war, he was a conscientious objector, performing non-combat jobs in army camps in the United States. The city would seem empty without him, but Wanda still wanted to return to New York that fall. She was pretty sure she could

earn money doing commercial art, and she still wanted to learn more about printmaking and art in general.

It all hinged on selling the house in New Ulm and making sure that the younger Gags weren't going to starve during the next winter. Finally, someone made an offer on the house, and by October it had sold. Soon the younger Gags were moving into an apartment in Minneapolis and Wanda was on her way back to New York. More good news was in the offing. Germany agreed to an armistice on November 11, ending the war in Europe. Wanda heard the news while looking for illustration work in New York: "I wanted to throw my arms about someone and whoop or cry—I didn't know which—but as there was no one adequate near by, I had to go on walking, my portfolio under my arm."

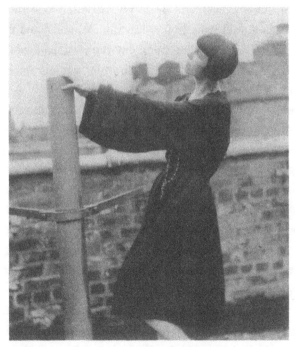

Wanda, sporting a new and more modern look, poses on a Manhattan rooftop not long after arriving in New York City, where she studied at the Art Students League.

The end of war and the end of worries about selling the house in New Ulm made Wanda jubilant, but her art and work in New York did not. She had no time for classes at the Art Students League and no money to pay for them. She hoped to make it on her own as a commercial artist—to do good by the many people who had helped her through art school and to send money back to the younger Gags. But work came in slowly. As Wanda put it later, it was a time of "sink or swim"—she would either make it in the big city or she would not.

At first, Wanda earned money painting designs on lampshades for twenty-five cents an hour. She slept in a friend's costume-making workroom to save on rent. She also sometimes danced with men in New York's large dance halls, earning as much as nine dollars a week in tips. Then she started working more and more for advertising companies, drawing what she called "stylish stouts," fashions for large women. When the women she drew weren't stout, they were impossibly thin. Wanda hated drawing these "artificial females," as she called them, but the work paid well. She earned enough to share an apartment with two other women on East Seventy-eighth Street.

Adolf Dehn, returned from the army, was living nearby with a few friends. One, a young man named Earle Humphreys, was unlike the rest of Wanda's New York acquaintances. He was not an artist. Although he talked of becoming a writer, he worked in a hotel dining room clearing dirty dishes from tables. But as Wanda discovered, he was more than just a bus boy and would-be writer. Earle instinctively knew that artists look at the world in a different way. He immediately understood that Wanda saw everything around her in terms of a drawing or a composition of lines, shading, and spaces. Wanda found it refreshing to meet a man who accepted her artistic ambitions and made her feel so comfortable.

Although Wanda loved Adolf Dehn "allover" and believed that theirs was a "deep" bond, she couldn't say that Adolf made her feel comfortable the way Earle did. In fact, she and Adolf—both ambitious artists out to prove themselves—often made each other miserable.

Wanda hated drawing the "artificial females" that advertising companies wanted from her, but she needed the money such commercial art jobs paid in order to live in New York.

In her diary Wanda frequently wrote about men (Adolf, Earle, and many others) who found her attractive. She also wrote about art and marriage. In one diary entry she tried to describe the perfect husband, a man "who would promise to get someone to do the scrubbing for me (I have been denied all talent for that art) and to run the house when I had a drawing streak." The description didn't fit Adolf well. His friend Earle Humphreys was a likelier candidate, had Wanda been considering marriage. But in New York, she was less and less positive about marrying at all. "I am not nearly ready to settle down and get married," she told her diary in 1920, "I'd make a punk [bad] wife anyway and I just couldn't imagine myself settling on one man for life."

Wanda decided that children, too, were out of the question: "Six youngsters and no money to give them an education proportionate to their capacities seems to me to be quite enough for one lifetime. And it is always a woman's art that has a hunk of years taken out of it [while raising children]—while the husband, or (to be broadminded), shall we say the father, can go on comparatively uninterrupted."

It was one thing to record important life decisions in her diary, but Wanda found life beyond the written page harder to control. In 1921 Adolf traveled to Europe to draw and study art. Wanda was expected to join him as soon as she had earned her travel money. "My one idea is Europe," she wrote that fall, "Half my trunk is packed." Yet she was spending more and more time with Adolf's friend Earle Humphreys. "And I—day after day I become more of a puzzle to myself," she confided in her diary. Although she still loved Adolf, she was, she admitted, "melting rather willingly into Earle's arms."

Wanda was changing from the innocent New Ulm girl who had once refused to let Adolf Dehn kiss her hand. For one thing, she looked different, cutting her hair so short it was like a glossy black helmet. She created her own filmy batik dresses that were a far cry from the long dark skirts she'd worn in Minnesota. Her name was changing, too. In the 1920s, she added an accent to Gág, making it clearer that it rhymed with *jog,* not *bag.* Even Wanda's attitudes were being transformed. In 1920 Wanda, along

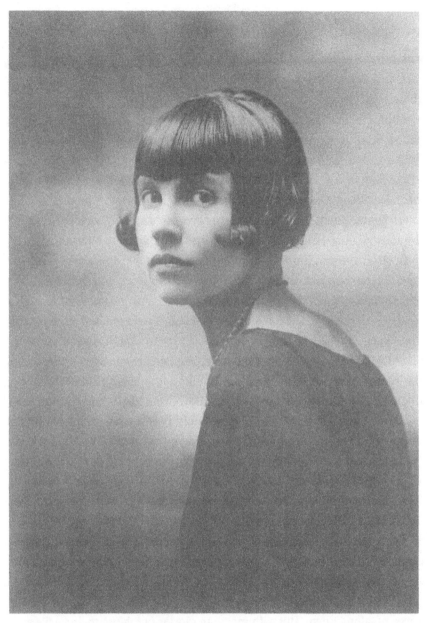

"My system of ethics is simple," Wanda wrote to a friend in the 1920s. "What's good for my work is good, and anything that hampers it is bad. Marriage would not make for progress in my work as far as I can see, so I don't bother with it."

with other American women, won the right to vote, and she began to cultivate an interest in politics. She also discovered new and different ideas about sex.

Although her trunk was half-packed for many months, Wanda never joined Adolf in Europe. She gave many excuses for remaining stateside, primarily that she had no money. Certainly she had lost a great deal of money when Happiwork, the business she'd been drawing for, went bankrupt in 1923. But Wanda's true reason for not going to Europe was that she had found contentment at home. "Art is my greatest passion," she wrote, "but at the present, just plain everyday passion is at the head of everything."

In 1924, she and Earle Humphreys rented a house in Chidlow, Connecticut, for the summer. Earle helped clean up the place and put in a garden while Wanda turned the barn into an art studio. For the summer and fall at least, she was leaving fashion drawings behind. "I've expressed other people's ideas long enough and now I'll express my own," Wanda vowed. Although she had longed to take time off before, she had always been either saving for Europe or trying to send money home to "the kids." By 1924, however, the kids didn't need her as much anymore. Stella and Asta were married and doing well. Of the younger Gags, only Flavia was still in school. She would soon graduate from Minneapolis's Central High. Then, at long last, Wanda's goal for the family—and her obligation to support the younger Gags—would be fulfilled. Already in the summer of 1924, Wanda was ready for a vacation from her obligations. She found it with Earle among the trees and plants of Chidlow.

That summer in the country was so satisfying for Wanda as an artist that she and Earle found an even cheaper place to rent for the next few summers— a tumble-down farm in rural Glen Gardner, New Jersey. They called the place "Tumble Timbers" because the old house appeared to be just on the verge of falling down. But with morning glories climbing up the walls and a luxuriant garden planted in front, the house was wonderfully *drawable,* as Wanda would say. It was also fairly roomy, and Wanda invited the other Gags to join her there.

SINK OR SWIM

Younger Gags had been moving closer to Wanda for some time. Tussy resettled in New York in 1922. Asta and her husband, Herbert Treat, followed in 1924. After Flavia graduated from high school and moved to New York, only Stella was still in Minnesota. Nearly all the Gags spent some time at Tumble Timbers in the 1920s, and Wanda loved the arrangement. Much like a mother hen, she found it easiest to watch over her brood when all gathered nearby. And she loved the fact that, in exchange for room and board, her younger siblings would do the cooking and scrubbing so she could draw.

At Chidlow and later at Tumble Timbers, Wanda started to find her way back to drawing and away from the stylized art she'd been creating for advertising agencies. She steered clear of drawing people. After so many years of churning out "simpering misses in lace and . . . fashionable ghostlings"—or super-thin women—along with the usual "stylish stouts,"

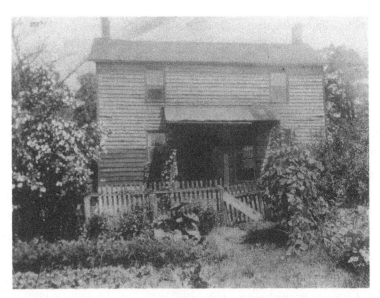

After spending a summer in Chidlow, Connecticut, Wanda and Earle Humphreys searched for a cheap place to live in 1925. They found it in a neglected old farmhouse they nicknamed "Tumble Timbers."

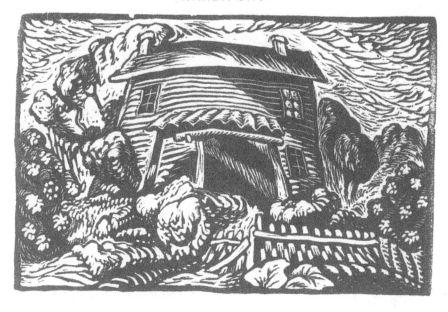

Tumble Timbers became the subject of numerous drawings and prints during
Wanda's stay there. This woodcut dates from 1925.

Wanda wasn't sure she could draw the human body as it really seemed to
her. Instead, she drew the hills and trees around her, the saggy metal bed
she bought at a farm sale, and the old kerosene stove Earle put together. As
Wanda put it later, "Draw the things about you . . . the very ordinary things,
such as chairs, stoves, woodpiles, frying pans, smoke stacks. Almost any-
thing is beautiful and *drawable,* if you can look at it in that way."

In the country, *everything* called out to Wanda to be drawn. "I'll never
look just like this again," the hillsides seemed to say, "better capture me
now!" To her friend Carl Zigrosser, director of a New York City art gallery,
Wanda wrote, "Yesterday I drew hills and trees to such an extent that I
dreamt about them most of the night. Not about trees and hills as they are,
but as I see them—as I draw them." She sketched the same scenes and the
same objects over and over again, changing the angle or lighting slightly,
adding or subtracting elements. Even though she might choose only one

SINK OR SWIM

drawing as the basis for a print, she realized that all of those sketches, or "studies," were vital in helping her see what she was trying to draw.

Wanda's training as an artist gave her the confidence to translate what she saw in her mind into images on paper. And her training in commercial art, where deadlines were all-important, helped her work quickly and efficiently. Because she had grown familiar with different printing techniques over the years, she could also draw with the end product (be it a woodblock or a lithograph) in mind. When Wanda had her recurring dream of meeting her father and showing him her recent work, she could, at long last, show him something she believed in.

Many of those recent drawings were of Tumble Timbers. Carl Zigrosser, a New York gallery owner, bought all of Wanda's drawings from 1925—

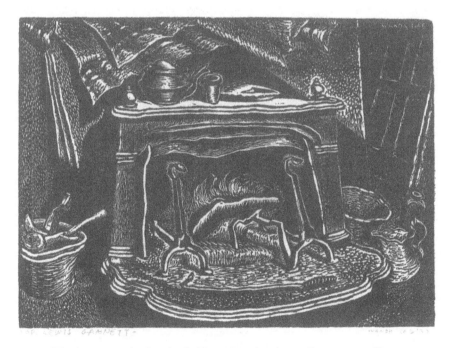

Wanda constantly sketched objects from her immediate surroundings, such as this Franklin stove, shown in a wood engraving from 1927.

most from Tumble Timbers. Zigrosser sold Wanda's work in his art gallery, providing her with enough money to continue renting the Connecticut farmhouse. By the end of her second visit there, from April to October of 1926, Wanda had amassed a large collection of new drawings and prints. Zigrosser was so pleased with her work that he promised to put together a special one-woman show—highlighting her artwork all on its own—at the Weyhe Gallery that November.

Wanda was thrilled to see her work filling the walls of the Weyhe Gallery, where she had so often gone to view the creations of promising new artists. "The pictures looked much better than I had ever seen them after they were all matted and hung on the wall," she told her diary. But it was terrible to think that now all the pictures of ordinary things around Tumble Timbers would be picked over and criticized by New York art lovers. Would they find saggy beds and old stoves beautiful, just as Wanda did? Would they buy any of her prints—giving her a chance to live off her art and return to the country for another summer?

At thirty-three, Wanda was scared and impatient to find out.

"The Cat Book"

Wanda's work was different from what people usually saw in art galleries in New York City. It wasn't old-fashioned; it was decidedly modern. Yet even for modern art, hers was unique. One of her prints, showing the strong diagonal lines of an elevated train station in the city, caused two women to call out to an art expert, "Oh. . . . Come and tell us what is happening here." Other prints, showing old boots and tools and the saggy roofline at Tumble Timbers, caused people to shake their heads: why would a fine artist spend her time drawing these "homely fragments of life," as one critic put it?

Yet overall the reaction to Wanda's first show was good. The *New York Post* wrote, "Miss Gág has a delicious point of view. . . . She lets you stand outside with her in the cold winter's night and peep furtively into the warmth and secrecy of a house's uncurtained window." *The New Yorker* was even more positive: "Miss Gág goes in for beauty and the homely quality of familiar things. You may have seen thousands of dishpans and kitchen chairs rendered on paper. But when you see Wanda Gág's you will jump."

Wanda was thrilled by the response—and by the sales of her work. "About 22 drawings were sold—almost $600 worth, of which I get 2/3," Wanda told her diary later, "Whatever regrets or misgivings I had about my show at the beginning were certainly dispelled before many days had passed." Finally she was earning enough from drawing what she wanted to draw that she didn't have to take on freelance work with advertising firms. What's more, it never felt like work: "All I could think of was, 'I had a lot of fun doing them.'"

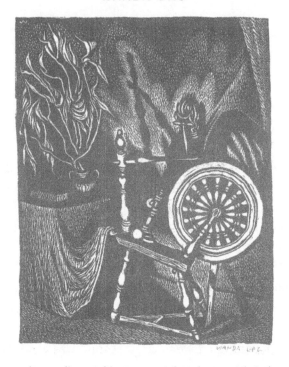

Wanda focused on ordinary objects more often than people in her drawings
and prints, but the objects she drew never looked lifeless. "A still life is never *still*
to me," she explained, "it is solidified energy—and space does not
impress me as being empty."

That feeling of fun stayed with Wanda as she drew and painted through
the summer of 1927, again at Tumble Timbers, and prepared for another
one-woman show at the Weyhe Gallery. By early in 1928, Wanda's art was
appearing regularly in *New Masses,* a liberal political journal, and she was
becoming well known in the New York art world. Critics and collectors
weren't the only people to attend her second show that March.

One was Ernestine Evans, an editor in the relatively new field of publish-
ing for children. Certainly many books for children had been created in the
past, but only in the 1920s were American publishers setting up separate
departments just for the creation of illustrated children's stories. Evans

worked for Coward-McCann in New York, and part of her job as an editor was to seek out new and talented illustrators. After seeing the exhibit at the Weyhe Gallery in March, Evans immediately asked to talk to Wanda.

At that first meeting, Evans was thinking of a story by another Coward-McCann author that needed an illustrator. But she stopped short of offering Wanda the job. The Weyhe Gallery show had convinced Evans that Wanda

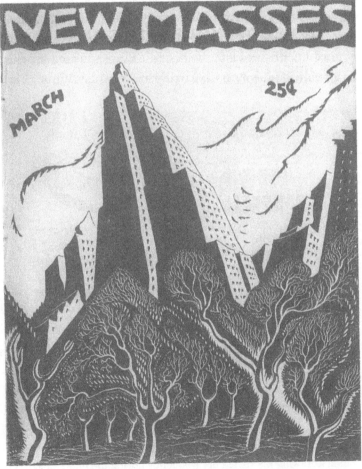

An example of a Wanda Gág cover for *New Masses* from the mid-1920s

Gág was an unusual and interesting artist. (Evans described Wanda's drawings later, saying, "I always wanted to reach out and touch them.") But, Evans wrote, "the bits she told me that first day—shyly, but directly, in answer to questions, never piling it on, but making you see New Ulm by words, and the table with the children eating supper and governing each other with 'Eat fair!'—were proof that she was a writer."

Ernestine Evans was on to something. She didn't know that Wanda had been writing in five-cent notebooks and old ledgers and on other paper scraps for nearly as long as she'd been drawing. She didn't know that when Wanda made new friends, she shyly showed them her drawings and prints but always boldly forced her diaries into their hands. Evans guessed something that Wanda already felt deeply: people would know her best through her *words*.

Wanda's drawing fits visited her frequently during the mid-1920s, when she created this lithographic print of springtime at her country garden.

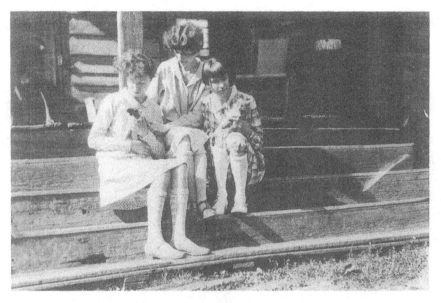

Flavia, Dehli, and Wanda relax on the steps of Tumble Timbers in the summer of 1928. They are holding Snoopy and Snookie, the two cats who served as models for *Millions of Cats.*

Evans asked if Wanda had written any stories that might work for children. Wanda said yes, offering to bring some to Evans's office. One was a story about cats, and it ended with a terrible battle between masses of them—millions of cats.

Wanda had first made up "Millions of Cats" while she was saving money for Europe and working for a company in Connecticut called Happiwork. The company went bankrupt, taking much of Wanda's savings with it. But Wanda emerged from the experience with several stories she'd told in her spare time to Joan and John, her employers' children. Wanda improved the stories based on the children's reactions. Whenever they grew "fidgety or listless," Wanda marked that section and rewrote it later. In about 1923, she'd asked her sister Dehli to type the cat story for her. Earle Humphreys liked it so much that he sent it to several publishers soon after, but it always came back rejected. Not this time.

In her 1928 picture book *Millions of Cats*, Wanda drew illustrations across two facing book pages (a two-page spread) and integrated the text with the art.

Pretty soon the very old woman saw them coming.
"My dear!" she cried, "What are you doing? I asked for one little cat, and what do I see? —

Evans loved the story on first reading and could imagine how it would look as a book, illustrated with Wanda's artwork. From its opening lines, the story seemed new and old at the same time: "Once upon a time there was a very old man and a very old woman. They lived in a nice clean house which had flowers all around it, except where the door was. But they couldn't be happy because they were so very lonely."

People asked, was it a story she'd heard somewhere, perhaps a folktale? "No," Wanda answered, "it isn't a folk tale. . . . I invented it . . . for some children in Connecticut who were always clamoring for stories." When pressed, Wanda admitted that it did *sound* like the German *Märchen* she'd

Wanda's design sense made her books visually interesting and unusual, but her story was deceptively simple. As she put it, "To write simply, but without dullness is one of the hardest jobs I can think of."

" Cats here, cats there,
Cats and kittens everywhere,
Hundreds of cats,
Thousands of cats,
Millions and billions and trillions of cats.

been raised on back in New Ulm. Wanda's first sketches, for their part, *looked* like New Ulm's most German-Bohemian neighborhood, "Goosetown," where the women still wore kerchiefs and the older men had long, flowing beards.

Ernestine Evans offered Wanda a contract for *Millions of Cats* in early April 1928. Wanda took on the project even though it would pull her away from creating fine art prints and drawings. It might be risky for her reputation to do commercial illustration for a "kid's book." But the job wouldn't last long. Evans wanted finished drawings in a few short months.

Wanda never approached the job as if it were "hack-work," as others

might term it. First she perfected the words, going over them as never before. What emerged at Tumble Timbers that early spring was a polished story of how a very old man goes searching for a single cat and brings home "millions and billions and trillions" instead. All but the most homely kitten die when the cats jump into a mad brawl over which one is prettiest. (Wanda, who had opposed World War I, may have been making a sly comment on the uselessness of war as a means of solving problems.) While Flavia and Dehli washed the dishes and cooked meals, Earle helped Wanda with revisions, suggesting that she repeat a refrain in the story, "Cats here, cats there, cats and kittens everywhere."

Once the story said all she felt it should, Wanda began mapping out the look of the book. She knew she had thirty-two pages to fill, so she divided the story into blocks and created a tiny folded dummy, or preview version, of the book. In the dummy, Wanda's illustrations appear only as pencil lines sweeping across the pages. But those lines suggested to Wanda the outlines of illustrations that were already forming in her head. These outlines she filled in further in rough sketches, then in preliminary ink drawings. For her models, she used two cats, named Snoopy and Snookie, that she drew over and over again in different poses. At last, Wanda created final ink drawings, subtly changing lines and expressions and using the blackest ink she could find. (As someone at Coward-McCann remembered later, "Black, to Wanda, meant *color* . . . rich, sparkling color.")

In some cases the finished illustrations were not single images for each page, as was usually done in children's books. Sometimes Wanda's illustrations filled the entire two-page spread, and the art seemed to wrap its way around the story. Wanda always hoped that the deep black color of the illustrations might be matched by a deep black color for the words. Typefaces didn't satisfy her, so she asked that the words be drawn by hand. When an initial sample was given to her, she was still dissatisfied. Eventually Wanda convinced Coward-McCann to hire her brother, Howard, to do the lettering. During the spring and early summer of 1928, Howard produced sample after sample of hand lettering until Wanda felt it, too, was just right.

"THE CAT BOOK"

The result was a book that, first published in September 1928, has remained in print, or always available for sale, into the twenty-first century. Anne Carroll Moore, the influential children's book reviewer for the *New York Herald Tribune,* wrote, "Wanda Gág sees everything as a child sees." Together, the art and pictures formed a pleasing package, and, Moore went on: "Everything lives in this book—cats, humans, trees, the little house."

Sales of what Wanda called "the cat book" were good from the beginning. And they didn't slow, even when much of the world plunged into a severe economic depression a little over a year later, on October 29, 1929.

Wanda demanded perfection. When *Millions of Cats* was reprinted in 1929, she told the printer: "I find the cover and endpapers very bad indeed. I think if you will compare the cut for the black plate with one of the first 'Cat' books, or, better still, with my original drawing which is in the office—you will agree that the plate has been horribly tampered with. I have marked only a few of these places. These are decidedly not my lines, and I shall always be sorry that thousands of copies of this have been allowed to go out as representative of my work."

In Wanda's 1929 picture book *The Funny Thing*, she uses a two-page spread
to give readers a visual tour of the home of Bobo, the story's hero. "His cozy little
home," Wanda wrote, ". . . was like a sort of tunnel under the mountain."

"Very well," said Bobo. "Sit down under
this tree and wait for me."
 The Funny Thing was all smiles
and did as he was told, while Bobo
went into his cozy little home,
which was like a sort of tunnel
under the mountain.

That day on the New York Stock Exchange, prices fell to historic lows, and
when investors went to banks for funds to cover their losses, many banks
failed and were forced to close. Many Americans lost their savings. Many
lost their homes and jobs.

Wanda and her artist friends felt the effects of the depression immedi-
ately. No one, it seemed, was buying fine prints or paintings anymore. But
Wanda was luckier than most of her fellow artists. *Millions of Cats* earned
her enough money in royalties (her percentage of profits from the sale of the
book) that she never had to worry about food or rent. Ernestine Evans was
so happy about the book's sales that she asked Wanda to do another picture
book from her pile of rejected stories. Wanda's next tale was called *The*

Indeed, the details of his house—the wood-burning stove,
the candle-lit kitchen—are not so different from the scenes Wanda sketched
of her own cozy home.

First he had to go through
his little bedroom. Next he came
to his study and finally he reached
the kitchen, where he usually made up
the food for the birds and animals.

Funny Thing. It was also written for Joan and John, who had first listened to
her cat book. Published in the fall of 1929, just as people everywhere were
feeling pinched for money, the book still sold many copies.

Evans wanted another children's book, fast, but Wanda resisted. "I just
can't bear the idea of grinding out a story 'to order' by a certain time," she
wrote, "and perhaps we had better have it clear between us that I will do a
children's book only whenever I am moved by an idea which seems unusually
good to me." Wanda's other reason for not creating a new picture book was
just as important. She needed time for drawing and painting and etching—
all things she couldn't do when deadlines for a children's book approached.

Wanda held off her publisher and returned to the world of fine art,

In her 1931 lithograph, *Grandma's Kitchen,* Wanda celebrated the humble
home of her Biebl grandparents, just outside New Ulm. She remembered the
"Grandma Folks" as always full of stories and ready to share the bountiful
food on their small farm.

mounting her third one-woman show at the Weyhe Gallery in 1930. She
worked so intensely on her art that she lost weight. To Ernestine Evans she
confided, "I am trying to take a good rest this summer, and hope to gain 5
lbs. at least—10 if possible." But by the next year, Wanda was working on
another "juvenile," as she called her children's books. *Snippy and Snappy,* a
tale of two mice striking out in search of adventure, gave Wanda the chance
to imagine and draw the world from a "mouse-eye-view." It also provided
her with funds to buy a more permanent home in the country.

In May 1931 Wanda and Earle bought an old farmhouse and property
near Milford, New Jersey, calling the place "All Creation." Even though the
house was in better shape than Tumble Timbers, Wanda and Earle put
hours of work into improvements and decorations. (Around the upstairs

bathtub, Wanda created a mural that included the beastly title character from *The Funny Thing* and cats from *Millions of Cats*.) The result was not exactly cozy—very old houses rarely are—but it suited Wanda's needs. She built an art studio on a hillside near the farmhouse, close enough so that she could easily walk to the house for lunch but far enough away so that she was never interrupted by visitors or phone calls.

If All Creation suited Wanda, it didn't always suit others. Living with an artist and author could be both fascinating and frustrating, as anyone who spent time with Wanda could attest. If Dehli put squash and tomatoes in a bowl on the table, Wanda might take the bowl over for a still-life drawing— and not let anyone eat the food. If Earle left his work boots by the stove after a day in the garden, Wanda might not let him wear them again until she'd had a chance to draw them in the golden glow cast by a kerosene lantern. And if visitors thought she was simply lounging under her umbrella on the grass and interrupted her work on a new children's book, Wanda might shine her dark and piercing eyes on them in a not-too-friendly way.

Flavia, who spent more time with Wanda than any of the other Gags, wrote a song celebrating the trials and tribulations of life with an artist. "If her biggest wish is getting out of dishes," went the refrain, "don't blame her, 'cause she's an artist!" But even if Flavia wanted to complain, she couldn't really: Wanda was her boss. In return for room and board, first at Tumble Timbers and then at All Creation, Flavia typed Wanda's manuscripts, answered the mail and the phone, cooked breakfasts, lunches, and dinners—and did the dishes.

Flavia also studied her big sister's work habits. On a typical rainy day, Wanda headed out the door at nine o'clock, "wrapped in a voluminous gray cape-coat, shod in high rubber boots and wearing a shabby boy's cap pulled down over her small head." She might say "Hello" to Flavia. Or she might not.

Flavia described the rest of the day this way: "Comes twelve o'clock and no Wanda. Comes one o'clock and still no Wanda. Comes two o'clock and ditto. Around two-fifteen or two-thirty she stages an appearance. 'Where were you so long?' I ask. 'Do you know what time it is?'

An example of a linoleum block print, Wanda's *Book Case,* 1929

"No, she doesn't. I tell her. She registers surprise.

"'Didn't you have your watch with you?'

"Oh, yes, she had her watch all right. But it wasn't running. No, there is nothing the matter with the watch—except that it never gets wound!"

Wanda might be able to ignore the hours of a rainy day by refusing or forgetting to wind her watch, but she couldn't stop time from passing. By 1933, she was forty years old. More and more, she was looking back on her life. What she saw caused her to ask hard questions: Had she done all that she'd set out to do as an artist and a writer? To what extent had she fulfilled her father's dying wish, to finish the work he'd begun? And if she hadn't fulfilled his wish yet, did she still have time?

Fairy Tales and Real Life

By the mid-1930s, Wanda Gág seemed to be living a fairy-tale life. The country as a whole was in the grip of hard times, but she was doing so well from sales of her children's books and fine art prints that she was able to lend money to the rest of her family. Coward-McCann sent her on tours to publicize her books, her prints hung on the walls of major museums, and newspapers wanted to tell readers her life story. (A typical headline read: "At 14 She Headed a Family of Seven But She Never Relinquished Her Dream.")

Coward-McCann had asked Wanda to write her autobiography as an inspiration to other young girls who might want to become artists and authors. But Wanda wasn't so sure an autobiography was the right format. Instead, she pored over her old diaries, starting with her father's ledger book from New Ulm. All through her early diaries were references to her father, Anton. "Dear papa," she wrote, "I will not let you die . . . when I feel myself slipping I will think this." In a later entry she added, "If I ever turn out anything worth while, I will not feel like saying that 'I did this,' but 'My father and I did this.'" Reading over her past made Wanda wonder if it all added up. Was she truly the artist who never relinquished her dream—or her father's dream?

Wanda feared that her most productive period as an artist might already be over. While she still created new prints, many were based on preliminary sketches she'd made years before. Many were filled with a sense of nostalgia, or a tender looking back on the past. For example, her 1935 lithograph *Uncle Frank's Workshop* showcased the crowded shed back in New Ulm where Wanda's uncles had created handmade wooden wonders, such

as a miniature merry-go-round for the Gag girls' dolls. Weeks and months passed between "drawing fits." And when those fits came, Wanda tended to revisit old themes.

Even in her writing, Wanda seemed to be looking back. After creating an alphabet book, *The ABC Bunny,* in 1933, Wanda wrote down an old story she remembered from childhood. It was published with her illustrations as *Gone Is Gone, or The Story of a Man Who Wanted to Do Housework* in 1935. Next, Wanda began reading and translating traditional folk and fairy tales collected in Germany and Bohemia in the early 1800s by two brothers named Jacob and Wilhelm Grimm. The brothers were scholars, but the stories they collected—known in German as *Kinder- und Hausmärchen* and in

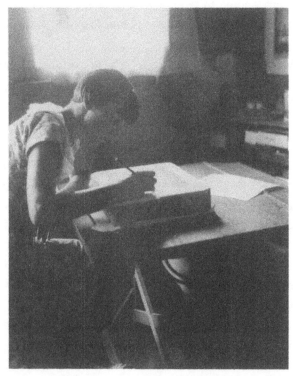

Wanda works on a lithographic stone in her studio at All Creation in about 1935.

FAIRY TALES AND REAL LIFE

In her 1936 book *Tales from Grimm,* Wanda returned to the fairy and
folk tales of her childhood. Hearing these old tales, she recalled, always gave her
"a tingling, anything-may-happen feeling."

English as *Grimm's Fairy Tales*—were immensely appealing to children.
These were the *Märchen* Wanda herself had grown up with.

The tales Wanda translated included stories of enduring popularity, such
as "Hansel and Gretel," "The Musicians of Bremen," and "Cinderella." But
she also translated less-well-known tales, such as "Spindle, Shuttle and
Needle," "Six Servants," and "Doctor Know-It-All." When she translated,
she usually worked in her bedroom, reading the Grimm tales in the origi-
nal German. Sometimes there were several different versions of the same
story, so Wanda selected the parts she felt worked together best. Often the
German was difficult to translate directly into English, so Wanda settled on
what she called a "free" translation. As she told her friend Schmidty, doing
so meant she'd be "true to the spirit rather than the letter, because I want to
show just what the *Märchen* meant to *me* as a child." Wanda also added rep-
etition and created her own dialogue where she thought it might help keep
children reading and entertained.

Just as in Wanda's earliest stories, elements of her own life crept into
her translations. In "Spindle, Shuttle and Needle," a poor orphan girl
wants to clean her cottage, so—with a magic spell Wanda might have wanted
to try—she sings "Needle, needle, sharp and fine; tidy up this house of
mine." And the needle (not unlike Wanda's sister Flavia) magically does it!

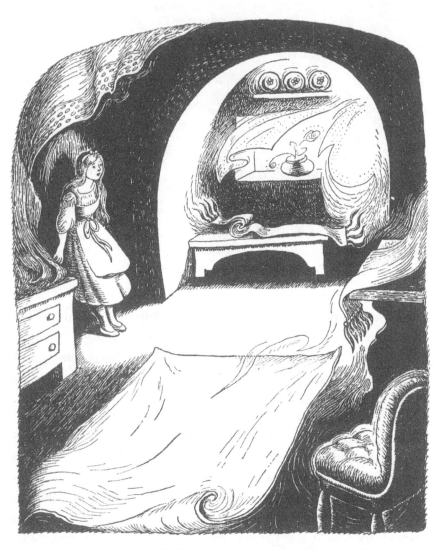

IT WAS JUST AS THOUGH FAIRY FINGERS WERE AT WORK

In her simple pen-and-ink drawings, Wanda was able to convey the magic of fairy tales, as when a poor orphan girl asks her enchanted needle "sharp and fine," to "tidy up this house of mine."

In the same story, when a handsome prince discovers that he loves a poor girl, he tells her happily, "Yes, you are poor but you are also rich—rich in many things." His words echo those of Anton Gag, who always proclaimed that he was "rich in children." And Wanda's description of Cinderella calls to mind her mother, Lissi, with "her winsome face, her modest air, and her graceful birdlike ways."

But Wanda's translations would not have been a success if they had only reflected her experience. *Tales from Grimm*, published with Wanda's illustrations in 1936, asked readers young and old to remember "the olden days when wishing was still of some use." Because Wanda always tested her stories on children and revised them to make them more appealing, these Grimm tales were not grim, but fun to read aloud. In "Cinderella," Wanda describes the stepsisters preparing for the ball this way:

> It took them all afternoon, and when they were finished they were worth looking at.
>
> They were dressed in satin and silk. Their bustles were puffed, their bodices stuffed, their skirts were fluffed and tufted with bows; their sleeves were muffled with furbelows. They wore bells that tinkled, and glittering rings; and rubies and pearls with little birds' wings! They plastered their pimples and covered their scars with moons and stars and hearts. They powdered their hair, and piled it high with plumes and jeweled darts.

This was a far cry from the way in which filmmakers such as Walt Disney transformed Wanda's beloved *Märchen*. In 1937 the movie *Snow White and the Seven Dwarfs* became an instant success—much to Wanda's dismay. The more she translated, the more Wanda was convinced that traditional tales were important to children. The old stories, she believed, had the power to balance out the harsher influences of modern life, "since [children's] lives are already overbalanced on the side of steel and stone and machinery—and . . . bombs, gas-masks and machine guns." Disney's *Snow White,* some critics felt, was not authentic, or true in spirit to the original tale. Too many modern translations, Wanda believed, were making the old

tales syrupy-sweet. Children, Wanda knew, *enjoyed* the goriness of the original tales because that goriness was usually not too terrifying—certainly not as terrifying as many aspects of modern life.

When Wanda's own version of Snow White was published in 1938, modern life was daily becoming more frightening. There were rumors of a coming war in Europe, where Adolf Hitler had risen to power in Germany. In Wanda's own professional life, the late 1930s were a mixed-up time. She could claim, as she did in her diary in the summer of 1938, that "In the juvenile [book] field, I may now, I suppose, just bragging, consider myself at the top." But few people took writing for children seriously. Wanda described what it was like to meet someone new at a party:

> "What sort of work do you do?" you are asked politely.
>
> "I write and draw."
>
> "For the magazines?" they ask eagerly. Or perhaps their eyes light up with that lion-hunting gleam as they say, "Do you write novels?"
>
> "No, I do books for children."
>
> "Oh, isn't that interesting," and that's that.
>
> You feel as though you had been relegated to the class of female china painters or as tho you were puttering around with baby stuff.
>
> But it is *not* baby stuff.

For Wanda, writing was always challenging, creative work, but it was also, she explained, "an outlet for only one side of myself." Her other outlet, creating artwork, was growing harder and harder for her to do. Wanda was no longer bothered by constant "drawing fits." In fact, she rarely had them anymore. In 1938, when she applied for a prestigious art fellowship to study painting, she didn't get it. (Her old boyfriend, Adolf Dehn, did.)

Wanda never avoided painting, but in art school she had focused on drawing and printmaking skills that might help her earn money as a commercial artist. Critics, such as her friend Carl Zigrosser at the Weyhe Gallery, frequently told her that her prints and drawings (all in black and white) were stronger than her color paintings. Perhaps just as significantly, painting

Wanda drew this caricature of herself for an exhibition of her work
at the Weyhe Gallery in 1937.

was her father's field. If she truly wanted to finish his work, as he had asked her on his deathbed, shouldn't Wanda be working with oil on canvas?

When she failed to win the painting fellowship, Wanda simply continued her study of oil painting on her own. Now that she was in her forties, it wasn't as easy to do as it might have been when she was young: "If I were not an artist I would doubtless consider my far vision fairly good, but just that which is so very important to an artist, i.e. the difference between sharp contours and those which disappear—that I am not able to distinguish clearly now." Despite these difficulties, Wanda pressed on, trying to do more and to see better what it was she wanted to paint.

She also found time to finish editing her early diaries. Entries from Wanda's teens and twenties, in the years before she left Minnesota, were published in 1940 as *Growing Pains: Diaries and Drawings for the Years 1908–1917.* The book sold well even though the depression was not yet over. People

responded to the story of Wanda's struggle to become an artist after her father's death. The world she described—of German-speaking folks in small-town America at a time when automobiles and telephones were still rarities—already seemed terribly old-fashioned. Readers knew that the dreamy teenage artist of *Growing Pains* had gone on to become a famous artist and writer. That she wrote fairy tales seemed apt, for Wanda Gág appeared to have risen out of "the olden days when wishing was still of some use." To readers of *Growing Pains* it seemed that she had lived a fairy-tale life.

But reality always finds its way into life, as it only sometimes does in fairy tales. In 1941, the United States entered World War II and times grew hard again, even as the depression neared its end. For Wanda, the coming of war brought change at home. There were wartime food shortages to deal with and the fear that Howard, now working as All Creation's caretaker, might be drafted into the army. (He was found to have health problems, most likely from poor eating as a child, that made him unfit for service.)

Earle Humphreys was frequently away at work. By 1943 he was making good wages in a machine shop, but soon his job was threatened. Somehow his employer found out that Earle and Wanda, who lived together, were not married. Earle's boss threatened to fire him.

Wanda and Earle had never considered marriage to be an important way of showing their love for each other. "After all," Wanda told her diary, "if two people have held each other's trust and interest for twenty years without legal bonds, a much deeper, stronger bond has already been forged." But Earle proposed and Wanda accepted—all so he could keep his job. After the "I do's," Wanda made a point of always wearing a "20¢ Woolworth ring."

Wanda acted as if her marriage had little importance. She jokingly called it "really truly holy wedlock!" But she had to admit that things changed once she and Earle were married: "Altho we laughed over it and didn't take it too seriously . . . we did feel *different* and more married."

When Alma Schmidt visited All Creation in December 1944, she saw differences in Wanda, too. That winter Wanda seemed tired, often napping in

the afternoon. She had lost some of her old driving energy and busyness. But she insisted nothing was wrong and set right to work helping Schmidty with a new project. Schmidty was planning to write a biography of the friend she still called "Inky." Wanda gave Schmidty all kinds of advice on her book, urging her especially to write about Anton Gag's influence. "What do you think," Wanda suggested, "of ending on the note . . . that I *did* carry out his wish of finishing what he was obliged to leave undone."

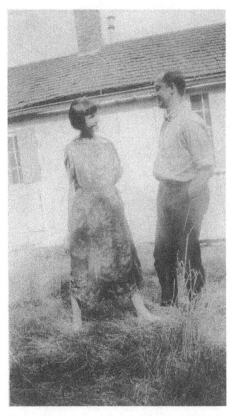

Wanda bought the rural New Jersey farm she called All Creation in 1931 with her longtime companion Earle Humphreys.

But trying to carry out her father's wish and trying to be both an author and an artist had left Wanda exhausted. By 1945 she was seeing specialists, looking for answers. Lately, she told the doctors, she'd been having trouble breathing. Was it an allergy or asthma—or even the tuberculosis that had killed Anton Gag? Wanda never learned the truth.

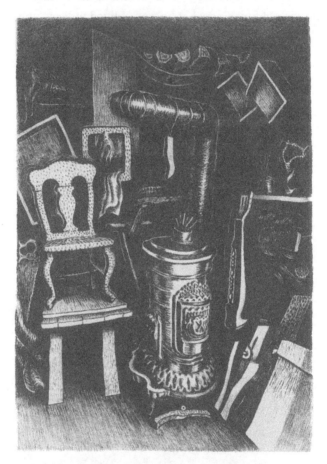

When Wanda created this lithographic print of her Uncle Frank Biebl's workshop, she was no longer experiencing frequent "drawing fits." Inspiration came to her more slowly in the last decade of her life, and she often looked to earlier sketches when creating new work.

Fairy Tales and Real Life

In fairy tales, bad witches and evil stepmothers die, while good children like Hansel and Gretel and princesses like Snow White survive. Wanda had always survived—and even prospered—when times were hard. She'd made up amazing stories to entertain her younger sisters and brother in New Ulm while worrying about how to get them through high school. She'd managed to study art when folks back home expected her to become a shop clerk. And she'd made pictures full of wonder and life even when she could barely pay the rent on a tumble-down farmhouse in the country. A successful author and artist at last, she'd lived a storybook life—not *"gloomy,* in any sense," as she reminded Schmidty. But even Wanda couldn't live forever.

Doctors performed exploratory surgery on her lungs in March. Then they gave Earle their diagnosis. Wanda was dying from lung cancer. It was not unusual in those days for doctors to tell the spouse, and not the patient, of the diagnosis. And it was Earle's choice not to tell Wanda the truth. She died on June 27, 1946, at the age of fifty-three.

Wanda had been in the midst of preparing another book of fairy tales, but she couldn't finish this job alone. Flavia, who like her big sister had always asked for a pencil over a penny, now picked up her pencil to complete Wanda's drawings. The book was published as *More Tales from Grimm* late in 1946. The girl from the storybook family, the girl with the dark, piercing eyes, had no more stories to scribble or pictures to paint, but the ones she left behind continue to tell the tale of her own storybook life.

GLOSSARY

armistice — an end to hostilities; truce

batik — a method of dying a print into a fabric; also, a cloth dyed in this way

Bohemia — a province of what was once the Austro-Hungarian Empire, now part of the Czech Republic

conscientious objector — a person who, for reasons of religious faith or conscience, objects to war and refuses to serve his or her country in a combat role

drafted — selected for military service

dummy — a model of a work to be published; a sample book

freelance — to sell one's services or work without a long-term commitment

linoleum print — artwork made by cutting an image in reverse on a layer of pliable floor covering, covering the cut surface with ink, and pressing paper to the inked surface

lithographic print — artwork made through a process of drawing an image on a flat surface, such as a lithographic stone, using a special pencil or crayon. After the surface is covered with water, ink adheres only to the crayon or pencil drawing, and a print may be made by pressing paper against the inked surface.

matted — artwork framed with a decorative border of cardboard

nostalgia — a bittersweet longing for things of the past

pandemonium — wild uproar or noise

pen name — a false name, used to hide a writer's true identity

pliable — easily bent or shaped; flexible

recitation — oral delivery of prepared lessons by a student

royalties — the share paid to an author or artist out of sales for his or her work

[sic] — in a quotation, indicates that the error or misspelling is part of the original text

GLOSSARY

stencil a sheet of cardboard with a design or letter cut out so that paint or ink can be applied to reproduce the pattern; also, an artwork made in this way

still life a painting or picture of objects such as flowers or fruit

superstitiously acting based on belief or chance rather than on the laws of nature

transom a small hinged window over a door

tuberculosis a contagious disease that often settles in the lungs

typeface a size or style of letters or characters used in printed material

zither a musical instrument made of a flat sounding box with thirty to forty strings stretched over it

CHRONOLOGY

1858 Anton Gag, Wanda Gág's father, is born in Walk, Bohemia.

1869 Elizabeth (Lissi) Biebl, Wanda Gág's mother, is born to a German-Bohemian family living in Harrisburg, Pennsylvania.

1886 Anton marries Ida Berndt on May 4 in New Ulm, Minnesota, where he works as a photographer and painter.

1887 Ida dies after giving birth to a baby, Antonia, who also dies not long after.

1888 Lissi Biebl begins working at the Gag photography studio in New Ulm at about this time.

1892 Anton and Lissi marry on May 16 in New Ulm.

1893 Wanda Hazel Gag is born on March 11 to Anton and Lissi Gag.

1894 Stella Lona Gag is born on October 24.

1897 The Gag family moves to 226 North Washington Street, New Ulm, before Wanda's fourth birthday in March. Thusnelda (Nelda or Tussy) Blondine Gag is born on April 4. Wanda begins German-language kindergarten at Turner Hall in the fall.

1899 Asta Theopolis Gag is born on July 22. In the fall, Wanda enters elementary school, where she encounters English.

1900 Dehli (Dale or Dell) Maryland Gag is born on December 4.

1902 Howard Anthony Jerome Gag is born on December 13.

1906 Anton is diagnosed with tuberculosis.

1907 Flavia (Flops or Flopsy) Betti Salome Gag is born on May 24. In the fall, Wanda goes to high school only part-time in order to help care for the younger children during her father's illness.

1908 Anton Gag dies of tuberculosis on May 22. In October, Wanda, age 15, begins keeping a diary in one of her father's old account books.

1912 Wanda graduates from high school in June and begins a year of teaching at a one-room school near Springfield, Minnesota, in November.

1913 In September, Wanda enrolls in the St. Paul School of Art, studying under a scholarship. She lives at the YWCA in St. Paul.

1914 Wanda begins classes at the Minneapolis School of Art in December.

1917 Lissi Gag dies on January 31. Wanda, age 24, and her classmate Adolf Dehn win scholarships to the Art Students League in New York.

1918 The younger Gags move to Minneapolis after the house in New Ulm is sold.

1924 Wanda and Earle Humphreys rent a house for the summer in Chidlow, Connecticut, and Wanda creates many drawings, prints, and paintings.

1925 Wanda rents Tumble Timbers, a house near Glen Gardner, New Jersey. She draws and paints extensively during this and the next several summers in the country. At about this time, she adds an accent to her last name, Gág, "to rhyme with jog, not bag please!"

1926 Wanda has her first one-woman show of artwork at the Weyhe Gallery, in New York City, in November.

1928 After Wanda's second one-woman show at the Weyhe Gallery in March, children's book editor Ernestine Evans offers Wanda a contract for *Millions of Cats.* Wanda completes the text and illustrations by midsummer.

1929 *The Funny Thing,* Wanda's second picture book, is published in the fall.

1931 In May, Wanda and Earle buy a farm near New Milford, New Jersey, eventually naming it "All Creation." Wanda's third picture book, *Snippy and Snappy,* is published.

1933 *The ABC Bunny* is published.

1935 *Gone Is Gone, or the Man Who Wanted to Do Housework* is published.

1936 *Tales from Grimm,* illustrated and freely translated by Wanda, is published.

1938 Wanda's illustrated translation of *Snow-White and the Seven Dwarfs* is published.

1940 *Growing Pains: Diaries and Drawings for the Years 1908–1917* is published in response to public interest in Wanda's childhood.

1943 Wanda Gág and Earle Humphreys marry in New York City on August 27.

1944 In December, Wanda's childhood friend Schmidty (Alma Schmidt Scott) visits All Creation to do research for a biography of Wanda.

1945 Wanda is diagnosed with lung cancer after exploratory surgery in March. She is not told of the diagnosis.

1946 Wanda Gág dies in New York City on June 27 at age 53. Her last book, *More Tales from Grimm,* is published later that year.

SOURCE NOTES

For full bibliographic citations, see the bibliography on pages 94–96.

Abbreviations

BCHS Brown County Historical Society, New Ulm, MN

CLRC Children's Literature Research Collections, Minneapolis, MN

MHS Minnesota Historical Society, St. Paul, MN

VPL Van Pelt Library, Philadelphia, PA

Page 3 "just like an artist should look" and "small and energetic" : Miss Schneider to Alma Scott, July 23, 1944, Scott Papers, MHS.

Page 3 "that they found complete enjoyment . . ." and "always got up and ran . . ." : Alma Scott to Wanda Gág, May 10, 1944, Scott Papers, MHS.

Page 3 "piercing dark eyes" : Moore, "Seeing It in Pictures," 6.

Page 3 "she loved drawing too well" : Miss Schneider to Alma Scott, July 23, 1944, Scott Papers, MHS.

Page 6 "An artist, wherever he goes . . ." : Anton Gag, "Notes by Anton Gag: On the Observation of Nature for the Education of a Painter," trans. by Delmar Brick, Gag Family File, BCHS.

Page 8 "Think of the coal bills!" : Quoted in Scott, *Wanda Gág,* 17.

Page 10 "offered excellent opportunities for climbing" : Wanda Gág to Alma Schmidt, undated, ca. 1944, Scott Papers, MHS.

Page 10 "A boy or a girl? . . ." : Wanda Gág, "Going to the Butcher Shop," Wanda Gág Collection, CLRC.

Page 11 "complete" Gág, : "These Modern Women," 691.

Page 11 "rich in children" : Scott, *Wanda Gág,* 16.

Page 11 "Had Papa really wanted a boy so much?" : Scott, *Wanda Gág,* 16.

Page 12 There they played below the pointy front . . . : James Boeck, curator at the Wanda Gág house in New Ulm, Minnesota, reports that over five hundred objects (doll limbs, doll clothes, paper dolls, pencils, marbles, and other

items) dating from Gág's childhood have been recovered from under the flooring of this front attic room. Many of the objects are on display at the house. (Interview with the author, May 22, 2004.)

Page 12 "Sit down, *Wandachen* . . ." and "a tingling, anything-may-happen feeling . . ." : Gág, *Tales from Grimm,* vii.

Page 12 "big deep forest" : Wanda Gág, "Paper Dolls," Wanda Gág Collection, CLRC.

Page 12 "all snug and tight" and "a princess in disguise . . ." : Wanda Gág, "Going Down to Grandma's," Wanda Gág Collection, CLRC.

Page 13 "Na, my little Wanda . . ." : Scott, *Wanda Gág,* 14.

Page 13 "When they're all together . . ." : Wanda Gág, "Snow-Shoveling," Gag Family File, BCHS.

Page 13 "When we have to look up words . . ." and "You see a word . . ." : Gág, "Snow-Shoveling," BCHS.

Page 14 "erased just as if it had been . . ." : Gág, "Snow-Shoveling," BCHS.

Page 14 "got stuck" and "She only let me go . . ." : Gág, "Snow-Shoveling," BCHS.

Page 14 "surely stay sitting at the end of the year" : Gág, "Snow-Shoveling," BCHS.

Page 15 "Mr. and Mrs. Marche found . . ." : Wanda Gág and Olga Mayer, "Velva's Glen," George Glotzbach Collection, BCHS.

Page 16 "like music or flowers or perfume" : Gág, "Going to the Butcher Shop," CLRC.

Page 18 *"Was der Papa nicht thun konnt . . ."* : Scott, *Wanda Gág,* 65.

Page 18 "of the pictures he had not finished . . ." : Herendeen, "Wanda Gág," 428.

Page 22 Ledger figures : Wanda Gág, *Growing Pains,* 5.

Page 23 "so we didn't have much for supper" : Gág, *Growing Pains,* 20.

Page 23 "nothing to live for" : Wanda Gág to Alma Scott, May 14, 1944, Scott Papers, MHS.

Page 23 "Mama is sick since last night . . ." : Gág, *Growing Pains,* 20.

Page 23 "This afternoon I didn't go to school . . ." : Gág, *Growing Pains,* 26.

Page 24 "the tragedy of mama's life . . ." : Wanda Gág to Alma Scott, May 14, 1944, Scott Papers, MHS.

Page 24 "A few days ago Margaret Kelly . . ." : Gág, *Growing Pains,* 1.

Page 24 "Fern Fischer was here yesterday . . ." : Gág, *Growing Pains,* 6.

Page 24 "How much of me did they really need . . ." : Gág, "These Modern Women," 692.

Page 25 "When I am in a drawing mood . . ." : Gág, *Growing Pains*, 69.

Page 25 *"Na was ist denn das? . . ."* : Flavia Gág, " 'Papa's Little Black Mouse,' " 37, Harm Collection.

Page 26 "Oh dear, I wish I could earn . . ." : Gág, *Growing Pains*, 32.

Page 27 "dressing so swell" : Gág, "These Modern Women," 691.

Page 27 "It just strikes me that . . ." : Gág, *Growing Pains*, 82.

Page 27 "It isn't nice to go shopping . . ." : Gág, *Growing Pains*, 51.

Page 27 "is on the right road . . ." : Quoted in Scott, *Wanda Gág*, 94.

Page 28 "we're trying to satisfy ourselves . . ." : Gág, *Growing Pains*, 44.

Page 28 "Any time you are ready . . ." : Gág, *Growing Pains*, 113.

Page 30 "How we revelled in English Lit. . . ." : Wanda Gág to Alma Scott, January 16, 1944, Scott Papers, MHS.

Page 31 "Each morning eighteen pairs of eyes . . ." : Wanda Gág, "My Schoolhouse," unpublished poem, Gág Collection, VPL.

Page 31 "Most of the people here . . ." : Gág, *Growing Pains*, 142.

Page 31 "the situation got pretty much . . ." : Quoted in Scott, *Wanda Gág*, 101.

Page 31 "Of course I know I was never . . ." : Gág, *Growing Pains*, 141.

Page 32 "My Own Motto . . ." : Quoted in Hoyle, *Wanda Gág*, 5.

Page 33 "I haven't a hint of inspiration . . ." : Gág, *Growing Pains*, 144.

Page 33 "I haven't had a drawing mood . . ." : Gág, *Growing Pains*, 144.

Page 33 "someone to talk to at last!" : Alma Scott to Wanda Gág, after May 23, 1944, Scott Papers, MHS.

Page 33 "a very polished English . . ." : Flavia Gág, " 'Papa's Little Black Mouse,' " 45, Harm Collection.

Page 34 "I am to go to Art School! . . ." : Scott, *Wanda Gág*, 106.

Page 35 "The work I did on them was poor . . ." : Scott, *Wanda Gág*, 109.

Page 35 "How could anyone even *think* . . ." : Scott, *Wanda Gág*, 110.

Page 37 "I am so *selfish* . . . " : Gág, *Growing Pains*, 244.

Page 37 "Mama has so much to think about . . ." : Gág, *Growing Pains*, 239.

Page 37 "They told me this morning . . .": Gág, *Growing Pains,* 236.

Page 38 "I dare hardly draw . . .": Gág, *Growing Pains,* 262.

Page 38 "Do you want to go to Art School . . .": Gág, *Growing Pains,* 314.

Page 38 "Well, I'll look into the matter.": Gág, *Growing Pains,* 315.

Page 40 "couldn't go on to school . . .": Alma Scott to Wanda Gág, spring 1944, Scott Papers, MHS.

Page 41 "had been fading away before . . .": Gág, "These Modern Women," 692.

Page 41 "given up": Herendeen, "Wanda Gág," 428.

Page 41 "Mittens wore out at the fingers . . .": Flavia Gág, "'Papa's Little Black Mouse,'" 37, 54–55, Harm Collection.

Page 46 "They're almost starving at home . . .": Stella Gag to Wanda Gag, Fall 1917, Gág Collection, VPL.

Page 46 "The kids have only $55 left . . .": Tussy Gag to Wanda Gag, January 1, 1918, Gág Collection, VPL.

Page 46 "Those foolish kids there . . .": Stella Gag to Wanda Gag, January 19, 1918, Gág Collection, VPL.

Page 46 "You must borrow money soon": Tussy Gag to Wanda Gag, January 1, 1918, Gág Collection, VPL.

Page 47 "I wanted to throw my arms about someone . . .": Quoted in Winnan, *Wanda Gág,* 209.

Page 48 "sink or swim": Flavia Gág, "'Papa's Little Black Mouse,'" 61, Harm Collection.

Page 48 "stylish stouts": Scott, *Wanda Gág,* 156.

Page 48 "artificial females": Wanda Gág to Alma Scott, January 16, 1944, Scott Papers, MHS.

Page 48 "allover" and "deep": Quoted in Winnan, *Wanda Gág,* 219.

Page 50 "who would promise . . .": Gág, *Growing Pains,* 177.

Page 50 "I am not nearly ready . . .": Quoted in Winnan, *Wanda Gág,* 213.

Page 50 "Six youngsters and no money . . .": Quoted in Winnan, *Wanda Gág,* 214.

Page 50 "My one idea is Europe . . .": Quoted in Winnan, *Wanda Gág,* 218.

Page 50 "And I—day after day . . ." and "melting rather willingly . . .": Quoted in Winnan, *Wanda Gág,* 219.

SOURCE NOTES

Page 51 "My system of ethics is simple . . ." : Wanda Gág to Harold Larrabee, September 24, 1923?, Wanda Gág Collection, CLRC.

Page 52 "Art is my greatest passion . . ." : Quoted in Winnan, *Wanda Gág,* 217.

Page 52 "I've expressed other people's ideas . . ." : Wanda Gág, "A Message from Wanda Gág," Scott Papers, MHS.

Page 53 "simpering misses in lace . . ." : Herendeen, "Wanda Gág," 429.

Page 54 "Draw the things about you . . ." : Wanda Gág, "A Greeting from Wanda Gág to You," 2, Scott Papers, MHS.

Page 54 "I'll never look just like this . . ." : Gág, "A Greeting from Wanda Gág," 3, Scott Papers, MHS.

Page 54 "Yesterday I drew hills and trees . . ." : Quoted in Winnan, *Wanda Gág,* 242.

Page 55 When Wanda had her recurring dream . . . : In a diary entry from February 15, 1915, in *Growing Pains* (354), Wanda talks of her recurring dreams of her father and how she shows him her latest sketches. I am making the assumption that the dreams continued.

Page 56 "The pictures looked much better . . ." : Quoted in Winnan, *Wanda Gág,* 245.

Page 57 "Oh. . . . Come and tell us . . ." : Quoted in Winnan, *Wanda Gág,* 246.

Page 57 "homely fragments of life" : *New York Herald Tribune,* November 21, 1926, quoted in Winnan, *Wanda Gág,* 29.

Page 57 "Miss Gág has a delicious point of view . . ." : Quoted in Winnan, *Wanda Gág,* 29.

Page 57 "Miss Gág goes in for beauty . . ." : Murdock Pemberton, *The New Yorker,* November 13, 1926, quoted in Winnan, *Wanda Gág,* 29.

Page 57 "About 22 drawings were sold . . ." : Quoted in Winnan, *Wanda Gág,* 246.

Page 57 "All I could think of was . . ." : Quoted in Winnan, *Wanda Gág,* 247.

Page 58 "A still life is never *still* . . ." : Wanda Gág, "Application for Guggenheim Fellowship," Wanda Gág Collection, CLRC.

Page 60 "I always wanted to reach out . . ." : Evans, "Wanda Gág As Writer," 182.

Page 60 "the bits she told me . . ." : Evans, "Wanda Gág As Writer," 183.

Page 60 when Wanda made new friends . . . : Alma Scott quotes Wanda as saying: "I often wonder that I have any friends at all. I always expect so much of them. I mean I expect them to take so much of me. I force my diary

extracts and letters on them whether they enjoy them or not and bother them with my good and bad ideas all mixed. It's as if I gave a basketful of peas to someone for a present, not sorted." (*Wanda Gág*, 118.)

Page 61 Joan and John : The little girl, Joan, to whom Wanda first read her cat book, grew up to be Joan Aiken, an acclaimed author of children's books.

Page 61 "fidgety or listless" : Wanda Gág, form letter to fans, ca. 1940s, Scott Papers, MHS.

Page 62 "To write simply . . ." : Wanda Gág, Miscellaneous notes on juvenile writing, undated, Wanda Gág Collection, CLRC.

Page 62 "Once upon a time there was a very old man . . ." : Wanda Gág, *Millions of Cats*.

Page 62 "No, it isn't a folk tale . . ." : Quoted in Moore, "Seeing It in Pictures," 6.

Page 63 "hack-work" : Gág, "Application for Guggenheim Fellowship," Wanda Gág Collection, CLRC.

Page 64 "Cats here, cats there . . ." : Comments on typescript for *Millions of Cats*, Wanda Gág Collection, CLRC.

Page 64 "Black, to Wanda, meant *color* . . ." : Dobbs, "Wanda Gág, Fellow-Worker," 191.

Page 65 "Wanda Gág sees everything . . ." : Moore, "A Distinguished Picture Book," 9.

Page 65 "I find the cover and endpapers . . ." : Wanda Gág to Mr. Cuthbert, August 28, 1929, Wanda Gág Collection, CLRC.

Page 67 "I just can't bear the idea . . ." : Wanda Gág to Ernestine Evans, February 5, 1930, Wanda Gág Collection, CLRC.

Page 68 "I am trying to take a good rest . . ." : Wanda Gág to Ernestine Evans, May 20, 1930, Wanda Gág Collection, CLRC.

Page 69 "If her biggest wish . . ." : Flavia Gág, "Who In All Creation?," 30.

Page 69 "wrapped in a voluminous gray cape-coat . . ." and "Comes twelve o'clock . . ." : Flavia Gág, "Who In All Creation?," 28, 29.

Page 71 "Dear papa, I will not let you die . . ." : Gág, *Growing Pains*, 227.

Page 71 "If I ever turn out anything worth while . . ." : Gág, *Growing Pains*, 239.

Page 73 "true to the spirit rather than the letter . . ." : Quoted in Scott, *Wanda Gág*, 177.

Page 73 "Needle, needle, sharp and fine . . ." : Gág, *Tales from Grimm,* 70.

Page 75 "Yes, you are poor . . ." : Gág, *Tales from Grimm,* 72.

Page 75 "her winsome face . . ." : Gág, *Tales from Grimm,* 114.

Page 75 "the olden days when wishing . . ." : Gág, *Tales from Grimm,* 179.

Page 75 "It took them all afternoon . . ." : Gág, *Tales from Grimm,* 104.

Page 75 "since [children's] lives are already . . ." : Gág, "I Like Fairy Tales," 76.

Page 76 "In the juvenile [book] field . . ." : Quoted in Hoyle, *Wanda Gág,* 20.

Page 76 "What sort of work do you do?" . . . : Gág, Miscellaneous notes on juvenile writing, Wanda Gág Collection, CLRC.

Page 76 "an outlet for only one side of myself" : Gág, "Application for Guggenheim Fellowship," CLRC.

Page 77 "If I were not an artist . . ." : Quoted in Winnan, *Wanda Gág,* 282.

Page 78 "After all, if two people . . ." : and "20¢ Woolworth ring" : Quoted in Winnan, *Wanda Gág,* 289.

Page 78 "really truly holy wedlock!" and "Altho we laughed over it . . ." : Quoted in Winnan, *Wanda Gág,* 289.

Page 79 "What do you think . . ." : Wanda Gág to Alma Scott, January 16, 1944, Scott Papers, MHS.

Page 81 *"gloomy,* in any sense" : Wanda Gág to Alma Scott, May 3, 1944, Scott Papers, MHS.

Page 86 "to rhyme with jog, not bag please!" : Gág, form letter to fans, ca. 1940s, Scott Papers, MHS.

BIBLIOGRAPHY

Published Works by Wanda Gág

The ABC Bunny. New York: Coward-McCann, 1933. Reprint, Minneapolis: University of Minnesota Press, 2004.

Batiking at Home: A Handbook for Beginners. New York: Crowell, 1926.

The Funny Thing. New York: Coward-McCann, 1929. Reprint, Minneapolis: University of Minnesota Press, 2003.

Gone Is Gone, or The Story of a Man Who Wanted to Do Housework. New York: Coward-McCann, 1935. Reprint, Minneapolis: University of Minnesota Press, 2003.

Growing Pains: Dairies and Drawings for the Years 1908–1917. New York: Coward-McCann, 1940. Reprint, St. Paul: Minnesota Historical Society Press, 1984.

"I Like Fairy Tales." *Horn Book* 15 (March–April 1939): 75–80.

Millions of Cats. New York: Coward-McCann, 1928.

Nothing at All. New York: Coward-McCann, 1941. Reprint, Minneapolis: University of Minnesota Press, 2004.

Snippy and Snappy. New York: Coward-McCann, 1931. Reprint, Minneapolis: University of Minnesota Press, 2003.

"These Modern Women: A Hotbed of Feminists." (Published anonymously.) *Nation* 124 (1927): 691–93.

Published Works Illustrated and Translated by Wanda Gág

More Tales from Grimm. New York: Coward-McCann, 1947.

Snow-White and the Seven Dwarfs. New York: Coward-McCann, 1938. Reprint, Minneapolis: University of Minnesota Press, 2004.

Tales from Grimm. New York: Coward-McCann, 1936.

Three Gay Tales from Grimm. New York: Coward-McCann, 1943.

Books and Articles

Berman, Ruth, ed. *The Kerlan Awards in Children's Literature, 1975–2001.* St. Paul, MN: Pogo Press, 2001.

Cox, Richard. "Adolf Dehn: The Minnesota Connection." *Minnesota History* 45:5 (Spring 1977): 167–86.

Dobbs, Rose. "Wanda Gág, Fellow-Worker," in Dobbs, et al., Wanda Gág Memorial Issue.
Dobbs, Rose, et al. Wanda Gág Memorial Issue. *Horn Book* 23 (1947): 157–207.
Evans, Ernestine. "Wanda Gág As Writer," in Dobbs, et al., Wanda Gág Memorial Issue.
Gág, Flavia. "Who In All Creation?" In Berman, ed., *The Kerlan Awards in Children's Literature.*
Herendeen, Anne. "Wanda Gág: The True Story of a Dynamic Young Artist Who Won't Be Organized." *Century* 116 (1928): 427–32.
Hoyle, Karen Nelson. *Wanda Gág.* New York: Twayne Publishers, 1994.
L'Enfant, Julie. *The Gág Family: German-Bohemian Artists in America.* Afton, MN: Afton Historical Society Press, 2002.
L'Enfant, Julie, and Robert J. Paulson. "Anton Gag, Bohemian." *Minnesota History* 56:7 (Fall 1999): 376–92.
Moore, Anne Carroll. "A Distinguished Picture Book." *New York Herald Tribune Books,* September 9, 1928, p.9.
———. "Seeing It in Pictures." *The Book Dial* (Fall 1928): 6–7.
Scott, Alma. *Wanda Gág: The Story of an Artist.* Minneapolis: University of Minnesota Press, 1949. Reprint, New Ulm, MN: Brown County Historical Society and Wanda Gág House Association, 2003.
Winnan, Audur H. *Wanda Gág: A Catalogue Raisonné of the Prints.* Washington, DC: Smithsonian Institution Press, 1993. Reprint, Minneapolis: University of Minnesota Press, 1999.

Documentary Sources

Brown County Historical Society, New Ulm, MN.
Gag Family File, including artwork and stories from Wanda Gág's childhood and the childhood reminiscence "Snow-Shoveling," transcribed by James Boeck.
Glotzbach Collection
Alma Scott Collection
Children's Literature Research Collections, Andersen Library, University of Minnesota, Minneapolis, MN.
Wanda Gág Collection, including photo albums, scrapbooks, correspondence, several typed childhood reminiscences, and original artwork and typescripts for many of Gág's books.
Harm Collection, Bloomington, MN.
Personal Collection of Gary Harm, including Gág family photographs, artwork, notebooks, and the unpublished story "'Papa's Little Black Mouse,' The Story of Wanda Gág, Inky Mouse," by Flavia Gág.

BIBLIOGRAPHY

Minnesota Historical Society, St. Paul, MN.
Alma Schmidt Scott Papers, including Scott's correspondence and working papers for her 1945 biography of Wanda Gág.
Van Pelt Library, Department of Special Collections, University of Pennsylvania, Philadelphia, PA.
Wanda Gág Collection, including correspondence, diaries, and childhood reminiscences.

Interviews

James Boeck, Curator, Wanda Gág House, New Ulm, MN, May 22, 2004.
Gary Harm, nephew of Wanda Gág, Minneapolis, MN, June 10, 2004.
Pat Scott Kaiernes, daughter of Alma Schmidt Scott, Kansas City, MO, July 7, 2004.

Videorecordings

Wanda Gág: A Minnesota Childhood. Minneapolis, MN: OxCart Productions, Inc., 2005.

Websites

"Children's Literature Related Destination, Wanda Gág House."
http://www.childrensliteraturenetwork.org/events/destins/gaghouse.html
This web page of the Children's Literature Network provides an introduction to Wanda Gág's childhood home in New Ulm, MN, which is open to the public for tours.
"Minnesota Storytime: Reading Guides." http://www.thinkmhc.org/Literacy/mnstorylist.htm
At Minnesota Storytime, a project of the Minnesota Humanities Commission, click on the title *Millions of Cats* to download a printable guide to reading aloud Wanda Gág's best-loved children's book.
"Wanda Gág: Minnesota Author Biographies Project." http://people.mnhs.org/authors/biog_detail.cfm?PersonID=Gag173
The website of the Minnesota Author Biographies Project includes a short, illustrated biographical article on Wanda Gág with extensive links to related topics and sites.

INDEX

Page numbers in *italics* refer to illustrations.

Wanda's holiday drawing of the very old man and the very old woman with their chosen kitty appeared in *Look* magazine in December 1944

Picture Credits

Printed in the USA
CPSIA information can be obtained
at www.ICGtesting.com
JSHW082222140824
68134JS00015B/675